IMAGES
of America

LAWRENCE PARK

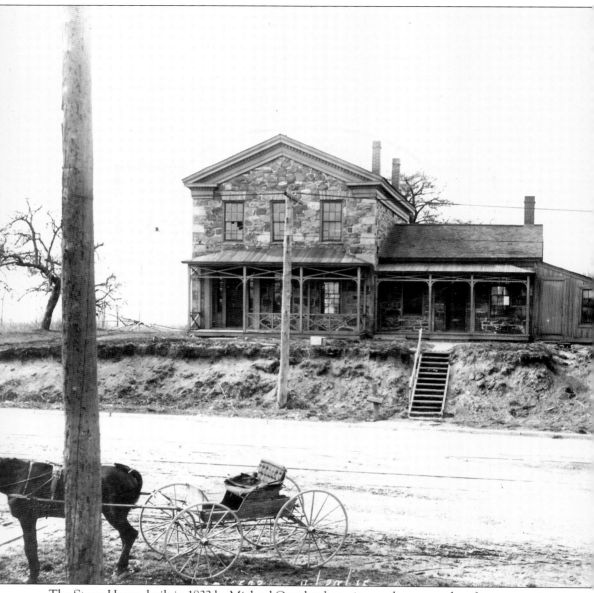

The Stone House, built in 1832 by Michael Crowley, has witnessed many modes of transportation, but when it was built, the horse and buggy were the primary means of getting around. Michael Crowley died in 1854 but Mary, his wife, and their family lived here until 1872. Folklore suggests that the Stone House was a station on the Underground Railroad. A tunnel leading from the house gives credence to the story. (Courtesy of Lawrence Park Historical Society.)

IMAGES
of America

LAWRENCE PARK

Marjorie D. McLean

ARCADIA
PUBLISHING

Published by Arcadia Publishing
Charleston, South Carolina

Printed in the United States of America

Library of Congress Control Number: 2010930338

For all general information, please contact Arcadia Publishing:
Telephone 843-853-2070
Fax 843-853-0044
E-mail sales@arcadiapublishing.com
For customer service and orders:
Toll-Free 1-888-313-2665

Visit us on the Internet at www.arcadiapublishing.com

*In appreciation for his patience, understanding, and
support in this and all my other adventures, I dedicate
this book to my husband, Lynn E. McLean.*

CONTENTS

ACKNOWLEDGMENTS

The history of Lawrence Park has been lovingly collected and preserved by the members of the Lawrence Park Historical Society. We are indebted to them for many of the photographs and written accounts that have made it possible to produce this book of the highlights of Lawrence Park history. It is hoped that this volume will trigger memories for readers as well as exclamations like, "I never knew that!"

We are grateful to many individuals who have written accounts of various happenings in and about Lawrence Park, and they include the following: C. Wesley Gillespie, Virginia Curtis, John Teker, Tom Crozier and his students, Virginia Andersen, Kevin Grant, Charlie Curtis, and the writers of the *GE Coupler* newsletter. Also, appreciation is given to the many individuals who have contributed photographs and anecdotes that have enlivened this book. Unless otherwise noted, all images in this book appear courtesy of the Lawrence Park Historical Society.

Accolades are due the volunteers at the Museum of Erie GE History who have done an outstanding job of presenting and sharing the story of the Erie Works and the beginnings of Lawrence Park. Their displays and photographs are of great interest to all who have an interest in the 100 years of the history of these two intertwined entities.

This history of Lawrence Park has been a joint effort to which Barbara Klaproth, professional photographer, contributed her skills and unfailing encouragement. I am deeply grateful for her willingness to devote her time, talents, and good judgment to bring this book to fruition. She made it possible to visualize the Lawrence Park of yesterday and today.

A special thanks go to my daughter, Sue Johnson, and my husband, Lynn McLean, for their proofreading skills and to my friends Shirley Westcott and Margaret Atkin for sharing their first-hand knowledge of the bygone days of Lawrence Park. I would also like to thank Hilary Zusman, Arcadia editor, who throughout this process has given Barb and me encouragement and assistance as we worked our way through the maze of recording the history of Lawrence Park.

INTRODUCTION

Lawrence Park, a suburb of Erie, Pennsylvania, owes its existence to the General Electric Company. In 1907, Frances Pratt, who was looking for a site for a new General Electric Company plant, visited his friend Matthew Griswold of Erie, Pennsylvania. Griswold convinced Pratt to recommend the area that is now Lawrence Park. The General Electric Company planned not only a manufacturing plant but also a community where their employees could live in comfortable surroundings. This was not to be a "company town" but rather a town developed in the "English garden" concept, with garden plots, green lawns, and many trees. Attorney James Sherwin quietly bought up 800 acres, and he and Griswold chose the name Lawrence Park. This was to honor Capt. James Lawrence whose flag carried the inscription "Don't give up the ship." This flag was flown on Capt. Oliver H. Perry's flagship, the *Lawrence*, and was carried to the *Niagara* in his 1813 naval victory on Lake Erie.

The Pennsylvania Population Company obtained and organized most of the land in the Erie Triangle, and in 1795, the first European settlers arrived here. Prior to that time, the Eriez Indians inhabited this area until they were conquered and assimilated into the Iroquois Confederacy. In 1797, Thomas Reese built a sawmill near the mouth of what came to be known as Four Mile Creek. The sawmill made it possible for Eliphalet Beebe to build the 30-ton sloop, the *Washington*, near the mouth of the creek. The ship was the first to be built on the south shore of Lake Erie and provided transportation for furs, salt, and passengers between Erie and Buffalo for 12 years. Early maps show that creeks in the eastern section of Erie County were named for distances from the center of Erie, thus, Four Mile Creek, Six Mile Creek, Sixteen Mile Creek, and so on.

Michael Crowley came from Ireland and in 1827 bought 399 acres of land along both banks of Four Mile Creek, from the lakeshore to Buffalo Road. In 1830, Michael divided his land into five sections and sold some of the sections to his brothers but kept the section near East Lake Road. His brother, Thomas, farmed and planted an orchard on the section closest to the lake. The dirt road that followed the west bank of Four Mile Creek and connected the East Lake Road to Wesleyville was known as Crowley Road, which is now known as Lawrence Parkway or Water Street.

In 1832, Michael Crowley built the Stone House on East Lake Road on the west bank of Four Mile Creek, facing Crowley Road. This sturdy dwelling with its 18-inch-thick walls was built in the Greek Revival style. Michael died in 1854 but his wife, Mary, and their family lived there until 1872. A local legend has long suggested that the Stone House was a station on the Underground Railway prior to and during the Civil War. There was a tunnel leading to the bank of Four Mile Creek. From there, it was short walk to the lakeshore where a waiting boat could take fugitive slaves to freedom in Canada. Recently discovered evidence of a tunnel gives credence to this tale.

The area east of the city of Erie, a part of Millcreek Township in the early days, was a favorite entertainment spot for horse racing enthusiasts. Reeds Driving Park was located on the East Lake Road, opposite the site that was later chosen by the General Electric Company to build the Erie Works. Exciting races were held at Reeds Driving Park from 1895 to 1909 on the very fast .5-mile

oval track. More than 100 horses were quartered on the grounds. In addition to the track, which was also used for bicycle races, there was a hotel and a baseball diamond.

In 1887, Jacob Lang and Christian Rabe bought 13 acres of Crowley's apple orchard and in 1888 built a handsome, three-story hotel with a wide veranda that afforded porch-sitters a beautiful view of Lake Erie. The Grove House Hotel, named for the extensive orchards surrounding it, was built in the French-style architecture of Eastlake design and was located on the bank of Lake Erie, just east of Four Mile Creek. This hotel was advertised as "the finest summer resort on the south shore of Lake Erie." Other attractions included good fishing, boating, bowling, concerts, and vaudeville. The Grove Park House Hotel also advertised having the best brands of liquors and cigars available. A rather interesting claim was that it was "a summer breathing spot."

A trolley line that brought patrons out East Lake Road to Reeds Driving Park extended its tracks across the fields (that are now part of the Lawrence Park Golf Club) to convey guests to Grove House Hotel. Also, the proprietors built a 200-foot pier to accommodate guests who would arrive by boat. A section of the concrete steps leading down the lake bank to the pier is still visible. Sadly, in 1902, the Grove House Park Hotel burned to the ground and was never rebuilt.

However, on the same site, a new entertainment venue was developed by Alfred Lang, son of Jacob Lang. Four Mile Creek Amusement Park had many attractions, a merry-go-round, roller coaster, midway with games of chance, a casino, theater, bowling alley, and a roller-skating rink. On August 3, 1915, a severe storm did considerable damage to the roller coaster and the trolley tracks, but with the tracks repaired, the park continued to delight young and old for many years. On Labor Day night in 1919, fire destroyed much of the amusement park. However, picnics were held at this site for several more years. Today this beautiful lakeside area is still bringing enjoyment to many, as the General Electric Company's picnic grove has occupied this site for many years.

By 1911, the General Electric Company had constructed Buildings 10 and 18 to produce foundry products and railway gas-electric car equipment. The company had 350 employees. The Lawrence Park Realty Company, headed by Nat White, laid out the first streets in Lawrence Park, which went as follows: Main Street from the General Electric Company's east gate, Rankine, Silliman, Smithson, and Spencer Avenues from Iroquois Avenue to Field Street. The streets were named for scientists, inventors, and engineers. On May 29, 1911, the Lawrence Park Realty Company offered 325 lots for sale costing from $300 to $600 and homes could cost no less than $1,600. Although Lawrence Park was designed to house employees of the Erie Works, sale of the homes was not restricted to employees of the General Electric Company Erie Works (now known as GE Transportation).

As John Teker, local historian, has stated, "If you want to look at the history of Lawrence Park, you have to look at the history of the General Electric Company Erie Works. The two are virtually inseparable." Lawrence Park began as a town to house employees of the General Electric Company and has grown and developed into a diverse community of caring individuals. Since 1979, the history of this unique community has been preserved by the members of the Lawrence Park Historical Society.

One

FOUR MILE CREEK ERA

The Four Mile Creek area has played an important role in the history of Lawrence Park. The sloop, *Washington*, was built at the mouth of Four Mile Creek in 1797. The area appealed to Michael Crowley, so in 1827, he purchased 399 acres of land on both sides of Four Mile Creek, located between the banks of Lake Erie and Buffalo Road. He divided the land into five sections and sold some of it to his brother, Thomas, but kept the portion that faced East Lake Road on the west bank of Four Mile Creek. Here, in 1832, Michael built a handsome Stone House in the Greek Revival style that had 18-inch-thick walls and was situated facing Crowley Road, which is now known as Lawrence Parkway or Water Street.

A duo of entrepreneurs, Jacob Lang and Christian Rabe, could see the potential of this area, so in 1897, they purchased 13 acres of the Crowley apple orchard on the bank of Lake Erie on the east side of Four Mile Creek. Here they built the elegant Grove House Park Hotel that provided its guests with beautiful views of Lake Erie and all the amenities of a first-class hotel. Unfortunately, it was destroyed by fire in 1902. Alfred Lang, Jacob's son, inherited the property and constructed the buildings and rides that became Four Mile Creek Amusement Park. This facility provided enjoyment to Erieites for many years until 1919, which was when it burned down.

The green space that Four Mile Creek provides still gives enjoyment to many as along its banks are the Napier Avenue playground, the Lawrence Park Golf Club, the Lawrence Park Fishing Club, and the General Electric picnic grounds.

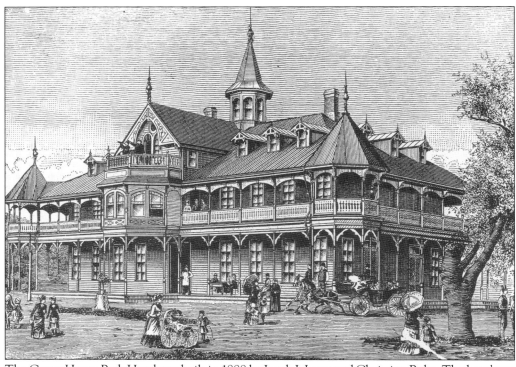

The Grove House Park Hotel was built in 1888 by Jacob J. Lang and Christian Rabe. The hotel was built in the French-style architecture of the Eastlake design at a beautiful location on the banks of Lake Erie, near the mouth of Four Mile Creek. The four corners of this three-story hotel were surmounted with towers, and a cupola rose from the center. The two-story veranda gave visitors beautiful views. The bar was stocked with the "finest foreign and domestic liquors, wine, cigars, beer, and so on," according to a *Morning Dispatch* advertisement on June 4, 1887.

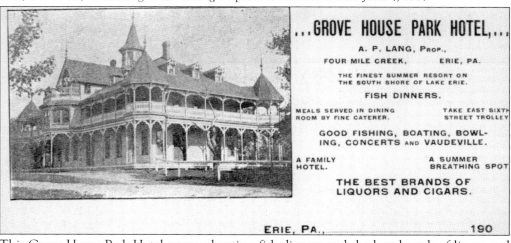

This Grove House Park Hotel menu advertises fish dinners and the best brands of liquor and cigars. The directions on the advertisement state, "Take the East Sixth Street trolley" (East Lake Road). The trolley line extended out East Lake Road in 1901 to "the finest summer resort on the south shore of Lake Erie." Sadly, this elegant hotel burned to the ground in 1902 and was never rebuilt, but the Four Mile Creek Amusement Park soon occupied this desirable site.

Reed's Driving Park was built by Charles Manning Reed on his property on the north side of East Lake Road, which is where Lake Cliff is now located. This park contained a very fast .5-mile oval track, a baseball diamond, and a hotel. At the Great Race Meeting in 1905, over 2,000 people paid 50¢ admission to the grounds.

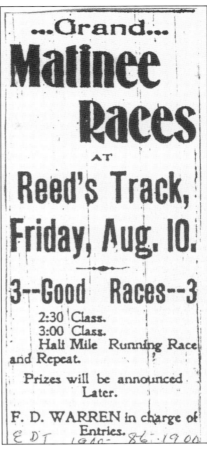

...Grand...

Matinee Races

AT

Reed's Track, Friday, Aug. 10.

3--Good Races--3

2:30 Class.
3:00 Class.
Half Mile Running Race and Repeat.

Prizes will be announced Later.

F. D. WARREN in charge of Entries.

E DT 1910- 86 1900

Trolley cars were the main method of transportation to Reeds Driving Park, Grove House Park Hotel, and later to Four Mile Creek Amusement Park. In the summer, there were "open cars" that provided breezy rides to these entertainment spots. An early map shows the trolley line traveling across the fields, which are now part of the Lawrence Park golf course, to the Grove House Park Hotel and the Four Mile Creek Amusement Park. (Courtesy of Carol Dolak.)

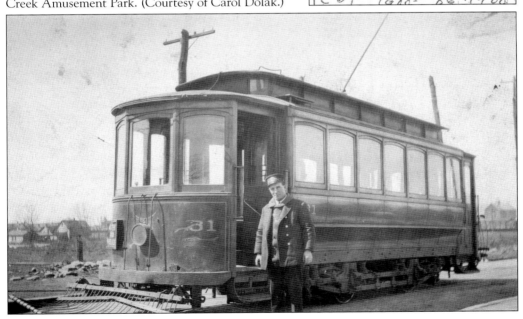

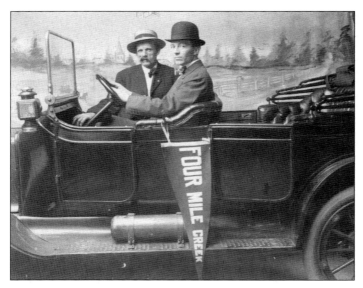

These gentlemen seated in a convertible seem to be posing for an advertising campaign to attract pleasure seekers to Four Mile Creek Amusement Park. It became a popular entertainment area, perhaps because it was "wet," while Erie's other amusement park, Waldameer, was "dry." This meant that patrons of Four Mile Creek Amusement Park were allowed to drink alcoholic beverages, and those that went to Waldameer were not allowed to have these types of refreshments.

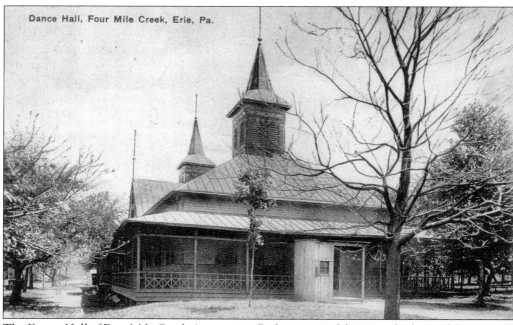

The Dance Hall of Four Mile Creek Amusement Park was one of the many facilities of this popular entertainment park in the early 1900s. The park was built on the bank of Lake Erie, adjacent to Four Mile Creek, where patrons could enjoy the lake breezes after an energetic dance.

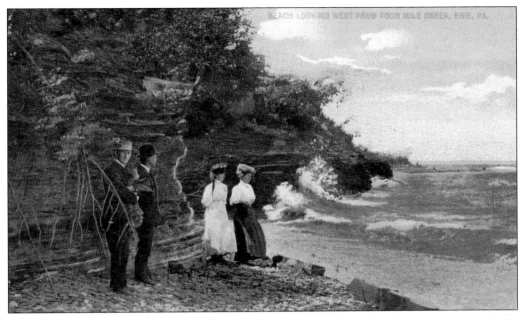

The beach on the shore of Lake Erie was a short walk from the Four Mile Creek Amusement Park. The individuals watching the waves crashing on the cliffs may have been cooling down from an exciting roller coaster ride or just enjoying a brief interlude with nature during the intermission of a play.

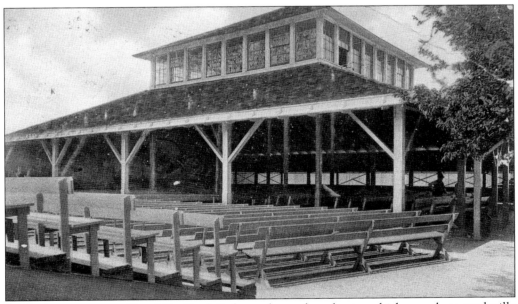

A popular attraction at Four Mile Creek Park was the outdoor theater, which was where vaudeville and burlesque shows were performed every afternoon and evening, except for Monday afternoons. An advertisement for one of the performances announced that there would be "black face singing, monologue, jugglers, comedienne, comedy acrobats, kinetography, and moving pictures."

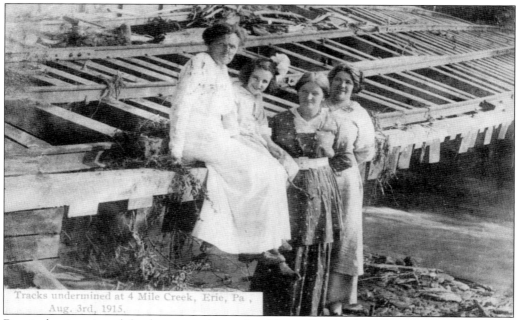

Tracks undermined at 4 Mile Creek, Erie, Pa ,
Aug. 3rd, 1915.

Despite having viewed the damage to the tracks of the trolley that brought these pleasure seekers from Erie to Four Mile Creek Amusement Park, the girls pictured here seem to be enjoying themselves. On August 3, 1915, the storm that caused the Millcreek flood in the city of Erie also caused Four Mile Creek to flood the amusement park.

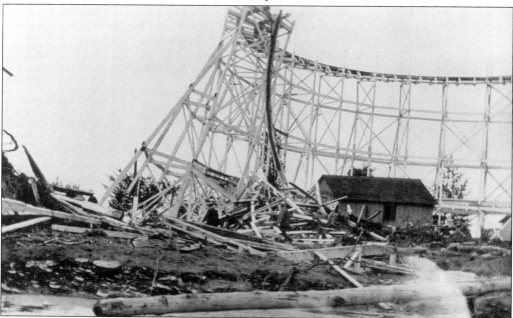

The roller coaster at Four Mile Creek Amusement Park suffered so much damage in the storm of August 3, 1915, that it had to be torn down. But the amusement park continued to give enjoyment to many until much of the park burned on Labor Day in 1919. The site still functioned as a picnic area, as the Lawrence Park Fire Department had its field day there in 1919 and 1920.

14

Two

A Town Is Born

Friendship is a priceless commodity. In 1907, Frances Pratt visited his friend Matthew Griswold. Pratt was on a search for an area to place a new "monster" plant for the General Electric Company. Griswold convinced Pratt that the area just east of Erie, Pennsylvania, from the lakeshore to the railroad tracks, would be an ideal location. It had access to water and rail transportation, relatively level land, and an existing double track trolley line going out East Lake Road that could provide transportation for workers.

Attorney James Sherwin quietly purchased 800 acres in this area, and in 1910, the General Electric Company began constructing Buildings 10 and 18. The General Electric Company planned not only a manufacturing plant but also a town. Sherwin visited England and other locations to observe characteristics of a planned community. Thus, Lawrence Park is based on the "English-garden" concept that provided for homes with garden spaces on tree-lined streets. The Lawrence Park Realty Company planted 700 shade trees that included birch, maple, sycamore, and horse chestnut. The leafy banks of Four Mile Creek provided a green space that would shield the town from the manufacturing plant.

Griswold and Sherwin considered names for this new town and finally decided on Lawrence Park to honor Capt. James Lawrence of "Don't give up the ship" fame. On May 29, 1911, the Lawrence Park Realty Company announced the grand opening sale of town sites in Lawrence Park. The beginnings of a caring community were soon evident with the erection of churches and the organization of civic associations.

In 1909, Matthew Griswold was president of a small shop located in Erie that was known as Pennsylvania General Electric. This building provided space for manufacturing that is until Buildings 10 and 18 were constructed at Lawrence Park in 1910. In 1911, the name was changed from Pennsylvania General Electric to General Electric Company Erie Works.

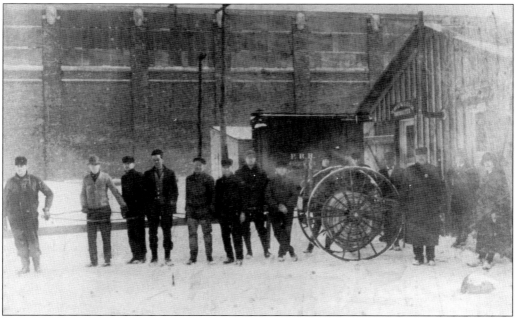

This two-wheel fire cart was to be pulled by volunteer firefighters who were from the construction force of the General Electric Company Erie Works. This photograph was taken when Buildings 10 and 18 were being constructed in 1910. Jack Sheldon, the first fire chief, obtained the much-needed, state-of-the-art equipment.

Although Capt. James Lawrence never heard of Lawrence Park, Matthew Griswold and James Sherwin decided on the name Lawrence Park to honor this courageous naval officer whose dying words were, "Don't give up the ship." This fledgling town embraced the motto in its struggles to become a first-class township and a caring community.

This Lawrence Park Townsite map of May 29, 1911, was included in the advertisement that announced the beginning of the building of Lawrence Park. Expert landscape engineers laid out the property and planned for all the utilities and trolley lines. By 1913, all properties had electricity and telephone lines. Buyers were not restricted to only those employed by the General Electric Company.

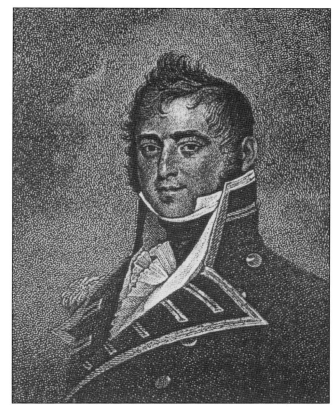

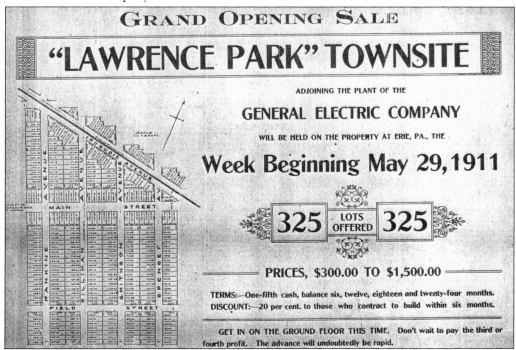

GRAND OPENING SALE

"LAWRENCE PARK" TOWNSITE

ADJOINING THE PLANT OF THE

GENERAL ELECTRIC COMPANY

WILL BE HELD ON THE PROPERTY AT ERIE, PA., THE

Week Beginning May 29, 1911

325 LOTS OFFERED **325**

PRICES, $300.00 TO $1,500.00

TERMS:—One-fifth cash, balance six, twelve, eighteen and twenty-four months.
DISCOUNT:—20 per cent. to those who contract to build within six months.

GET IN ON THE GROUND FLOOR THIS TIME. Don't wait to pay the third or fourth profit. The advance will undoubtedly be rapid.

Henry Keim's grocery store was one of the first stores on Main Street. Built in 1912 on the northeast corner of Main Street and Rankine Avenue, the store not only served the grocery needs of the 34 families that were then located in Lawrence Park, but the second floor also provided space for the very first school room, which was where Mary Allgier taught two students.

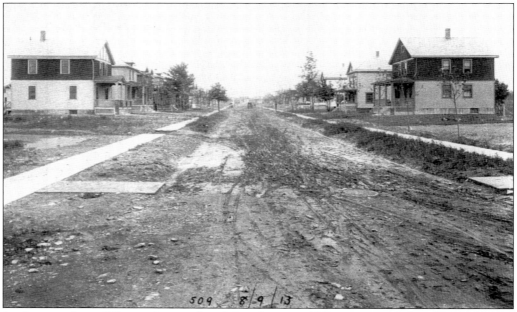

Looking south on Silliman Avenue from Main Street in 1913, one can see that the streets were not yet paved. The Lawrence Park Realty Company advertised that these most desirable homes would have all the amenities of electricity, gas, water, and sewer, plus paved sidewalks. The first house built was for George Debell at 1035 Silliman Avenue. Silliman Avenue was named for Benjamin Silliman, a Scot who was a prominent chemist at Yale.

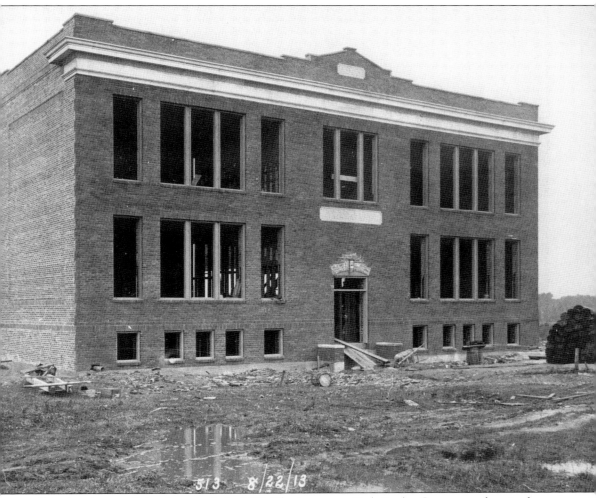

Priestley Avenue School was built in 1913. The Lawrence Park Realty Company advertised on June 5, 1912, "Arrangements have been made for school facilities to keep pace with any demand that may be made." Priestley Avenue School was a solid building that originally had only four rooms and an auditorium. Kindergarten was held at St. Mary's Parish house. The school was later enlarged and provided not only classrooms for students, but also in 1927, a "well baby" clinic under the auspices of Dr. Emerson, beloved Lawrence Park physician. Before Priestley Avenue School was built, school was held on the second floor of Harry Keim's store on Main Street, which was where Mary Allgier began teaching two students. Priestley Avenue was named for Joseph Priestley, who discovered oxygen in 1774.

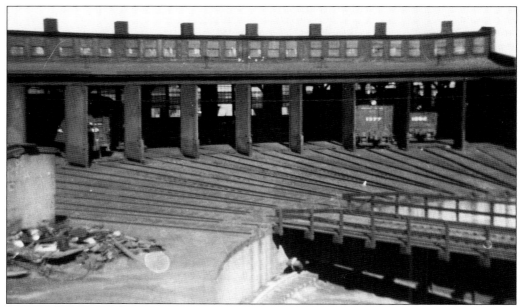

In 1913, the New York Central Railroad built a 16-stall roundhouse, located south of Bell Street and on property acquired from the General Electric Company. It was a coaling station, repair shop for trains, and a rest stop for the trainmen. There was a YMCA bunkhouse and a restaurant. Approximately 200 people were employed at this facility. The roundhouse was demolished in the late 1950s.

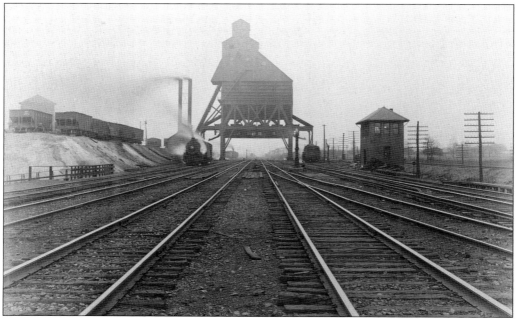

This massive coal tipple was a part of the roundhouse complex that was erected in 1913. The coal tipple enabled trains to refuel here in Lawrence Park. This operation continued until the advent of diesel engines, which meant coal was no longer needed as a fuel for engines. With no further use for it, the coal tipple was razed.

Looking north along Smithson Avenue from Field Street, this photograph, taken in 1913, shows that the streets were not paved at the time. A few of the houses on Smithson Avenue had natural gas wells. Smithson Avenue derived its name from James Smithson, who provided the means to found the Smithsonian Institution.

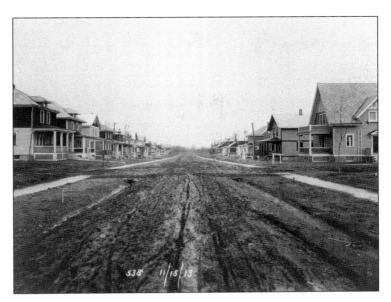

Albert Renshaw's family was one of the first families to settle in Lawrence Park. The family members are, from left to right, (first row) Albert, Kate, and Harry; (second row) George, Charles, Tom, William, and Julian. George Renshaw was the first baby to be born in Lawrence Park. Six the of Renshaw boys worked at General Electric Company.

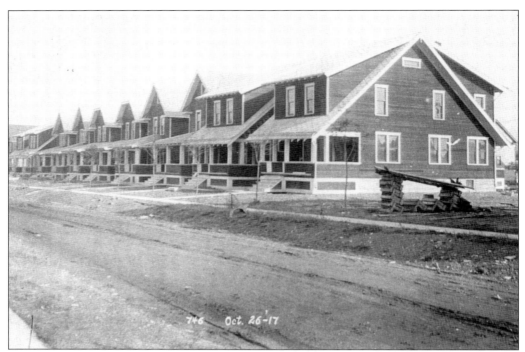

These homes on the east side of Rankine Avenue were built on lots sold by the Lawrence Park Realty Company. A stipulation of the sale was that houses must cost at least $1,000 on the $350 lots. True to the "English-garden" concept, the homes would have space for gardens, and the streets would be lined with trees.

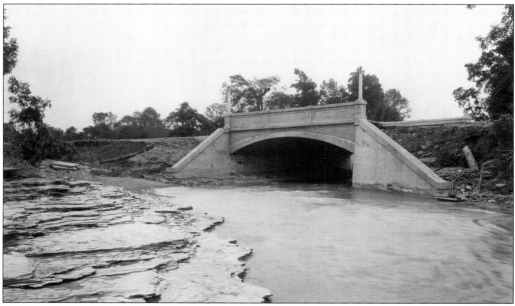

The 1915 flood of Four Mile Creek, which devastated the Four Mile Creek Amusement Park, washed out both sides of the bridge on Main Street. The bridge was quickly reinforced, as it provided the only access from the General Electric Erie Works to Lawrence Park.

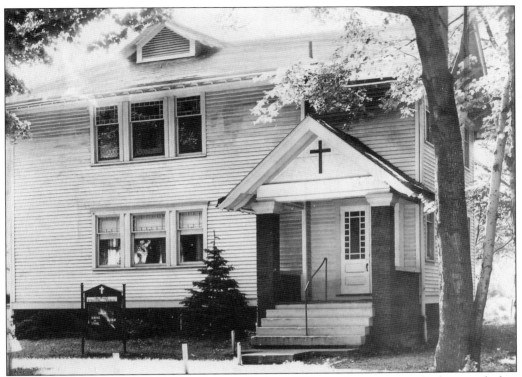

In 1914, St. Mary's Episcopal Parish Hall was built on Silliman Avenue, near the large park that was included in the design of the town. The congregation met for worship on the second floor of the parish hall, and the first floor was used as a meeting place by many organizations, including the Civic Association, volunteer firemen, Pennsylvania State Police Lodge, Red Cross, Boy Scout Troop 10, and the American Legion.

Substantial homes were built along lower Rankine Avenue about 1916. These homes were built for John St. Lawrence, W. H. Supplee, A. W. Thompson, and H. H. Bates, executives at the General Electric Company Erie Works. Rankine Avenue was named for W. J. M. Rankine, inventor of the steam expansion cycle.

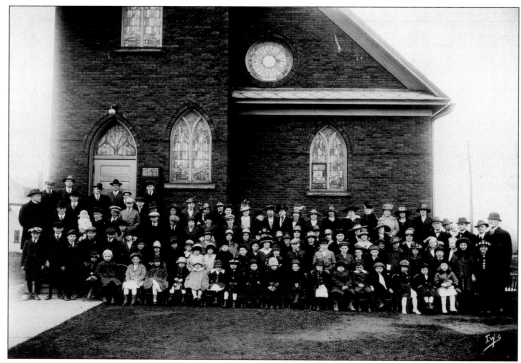

A large crowd attended the dedication of Christ Lutheran Church that was built on Silliman Avenue in 1914. The front row of very well-behaved children is indication of a good future for this congregation. Before their church was built, members met in the Priestley Avenue School and on the second floor of Keim's grocery store. A new Christ Lutheran Church was built in 1973 on the same site. (Courtesy of Christ the Redeemer Lutheran Church.)

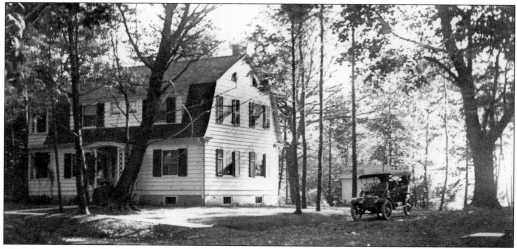

This home, located at the corner of Rankine Avenue and Emmet Drive, was built for Maj. W. H. Supplee in 1916. In later years, this gracious, Dutch-style, mansard roof house was the home of Wilhelm Johnson, the unofficial caretaker of Elbow Tree Park. In 1936, the name of this part of Napier Avenue was changed to Emmet Drive to honor Dr. W. L. Emmet (uncle of H. L. R. Emmet, general manager of Erie Works), who developed the steam turbine. (Courtesy of William McLean.)

Three

UNIQUE ROW HOUSES

During World War I, war production at the General Electric Company Erie Works created a need for many more employees. To house these additional workers, an amazing building project was undertaken in Lawrence Park in 1917. This resulted in the construction of brick row homes that provided housing for 494 families. Lawrence Park took on a European appearance with its curvilinear streets and row-type houses.

The larger duplex houses were usually built on corner lots and were called Perry houses. The Lawrence Houses were in units of four, five, six, or eight. The Niagara houses had 8, 10, or 12 units. The Lawrence Clubhouse on the southwest corner of Main Street and Rankine Avenue contained rooms for boarders, a living room, a dining room, a pool hall, and a barbershop. This venerable building later became the headquarters for United Electrical Local 506.

Lawrence Park was a part of Millcreek Township when the Lawrence Park Junior-Senior High School was built on Morse Street in 1924. Students still had to take the trolley to East High School to complete their junior and senior years of high school. The first class to graduate from Lawrence Park High School was the class of 1933.

Prohibition was the law of the land from 1920 until 1933, and as Lawrence Park extended to the shores of Lake Erie, there were several landing spots for rumrunners to unload their cargos. Many Lawrence Park residents can recall hearing interesting stories about these activities.

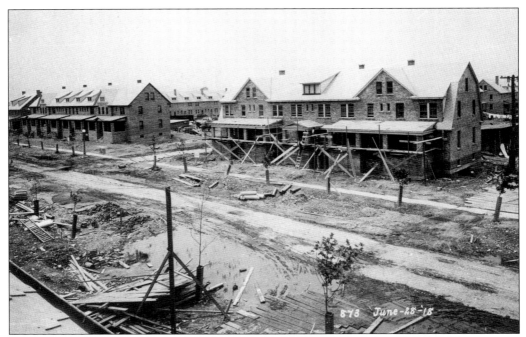

During World War I, construction of 494 row-type homes provided much-needed housing for war workers. General Electric Company Erie Works had a large contract to build steam turbines for submarines and destroyers, which necessitated many additional employees. These sturdy row-type houses that were built during World War I are still providing homes for the Lawrence Park residents.

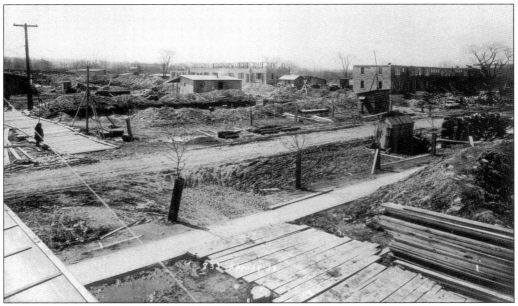

During the early years, when so much construction was taking place, planks had to be laid over intersections that were heavily rutted by horses and wagons. Streets were eventually paved, sidewalks were put in place, and the battle with mud was finally won.

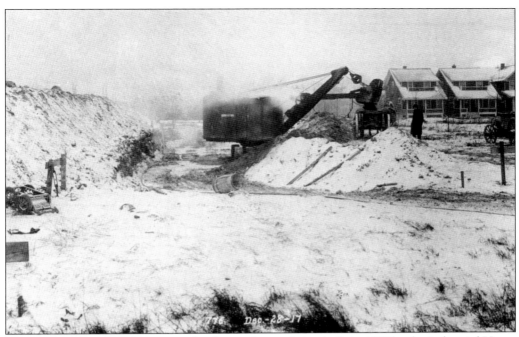

Excavations along Bell Street were for the row homes being built in 1917 by the Industrial Home Company. A total of 494 homes were provided for General Electric Company Erie Works employees and others. Bell Street was named for Alexander Graham Bell, inventor of the telephone.

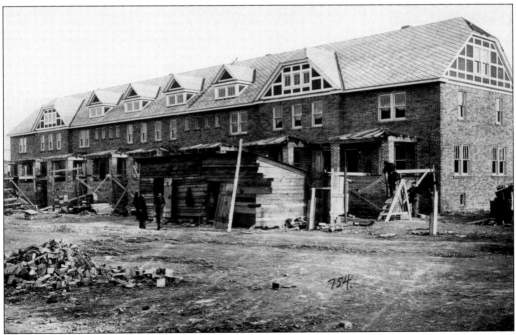

The firm of J. A. Maas had the contract to build many of the multifamily row houses. These at Rankine Avenue and Field Street were rented for $15 a month in 1918. Field Street was named for Cyrus Field, a U.S. capitalist who promoted the first Atlantic Ocean cable.

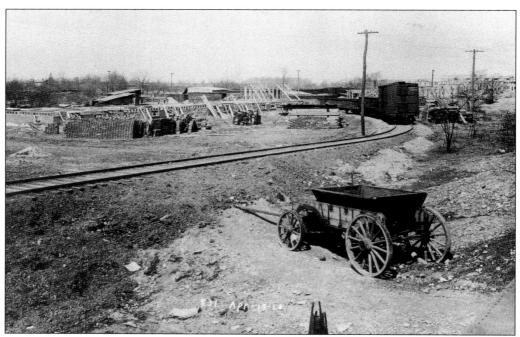

This view looking northwest from Rankine Avenue and Field Street shows the tracks that were used to bring in materials for the massive building project of 1917 and 1918. The wagon in this photograph of April 19, 1918, shows another means of transporting materials.

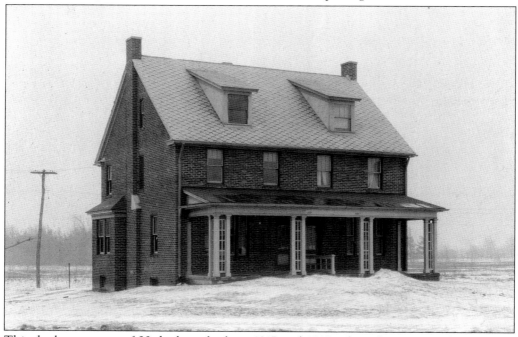

This duplex was one of 23 duplexes built in 1917 and 1918, when the row-type houses were constructed. Duplexes like this were usually built on corner lots and were called Perry houses, in honor of Capt. Oliver H. Perry, hero of the naval battle on Lake Erie in 1813.

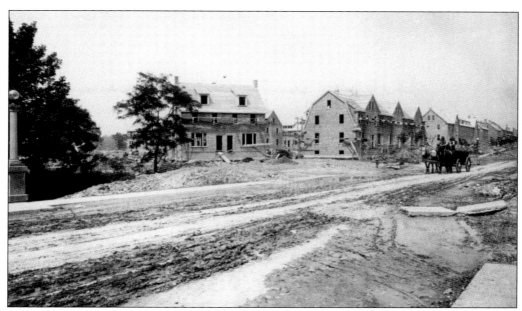

Main Street was still unpaved in 1918, but the handsome bridge with its graceful lamps gives a hint of what this important street will look like in the future. Horses and wagons were involved in much of the heavy work of building this new town. A duplex and row houses are under construction in the background of this June 28, 1918, photograph.

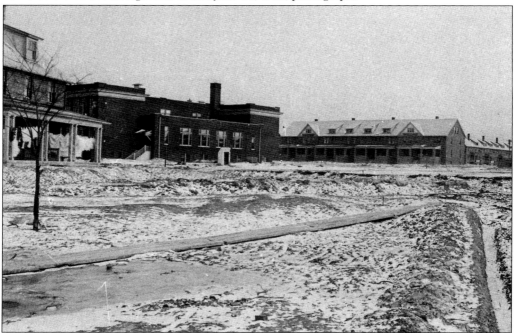

Row houses were beginning to surround Priestley Avenue School. By 1918, the school had an addition built onto the back of the original schoolhouse. Hanging newly washed clothing on the porch was a common sight in those days. In the foreground, the beginnings of Napier Avenue can be seen.

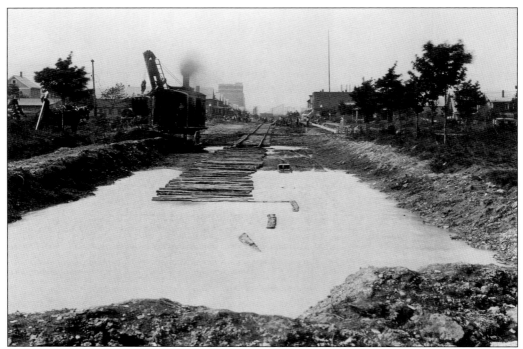

In this photograph, Main Street appears to be flooded, not by Four Mile Creek but by a prolonged heavy downpour. Despite these conditions, the massive building project of 1917 and 1918 continued unabated, as the need for additional housing was so critical.

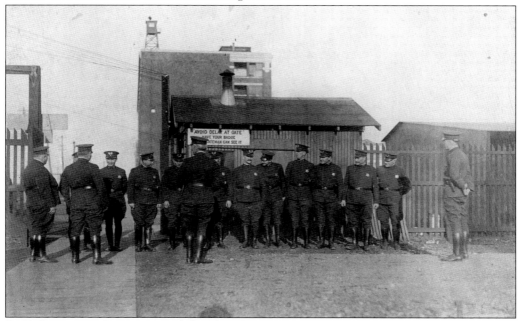

In 1919, a group of security guards lined up for inspection. During World War I, the Erie Works was heavily involved in war production, and the increase in employment necessitated a more vigilant control of the buildings and grounds.

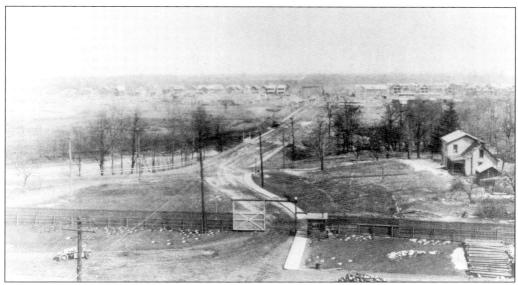

A view of Main Street from the east gate of the General Electric Company Erie Works in 1918 shows a portion of Crowley Road. In 1920, the decision was made to change the name to either Lawrence Park Boulevard or Lawrence Parkway. Lawrence Parkway won; however, in recent years, the name Water Street, the name given to this road in Wesleyville, appears on the road signs.

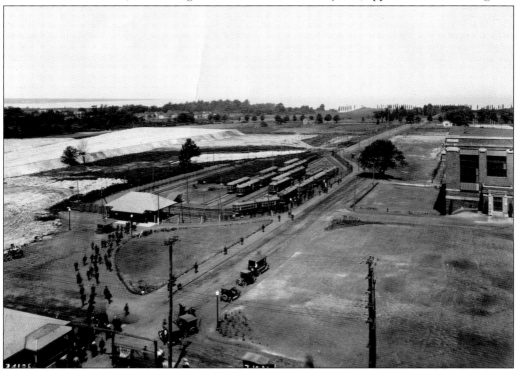

A yard full of trolleys at the General Electric Company Erie Works attests to the fact that many workers depended on this form of transportation. For the General Electric Company, the East Lake Road trolley line was one of the deciding factors to build in Erie. Trolley fare in 1916 was 5¢.

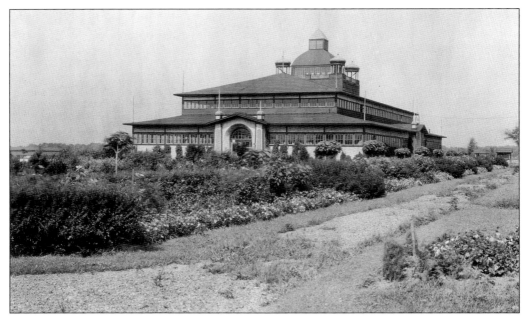

Although not in Lawrence Park, the Erie Exposition Grounds were located on Iroquois Avenue, near Fair Avenue. In 1920, the Erie Exposition Grounds contained a large exhibit hall and also a horse racing track with a grandstand. General Electric Field Days were held here for several years.

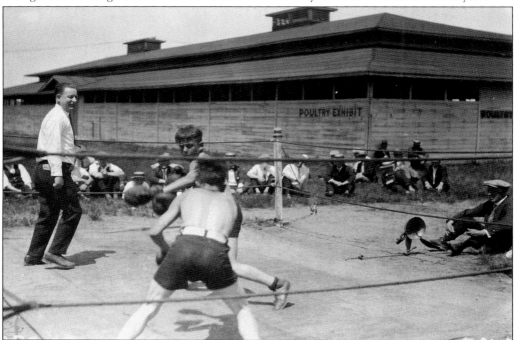

Boxing was one of the many sporting events sponsored by the General Electric Athletic Association (GEAA). This bout is being staged at a field day that was held at the Erie Exposition Grounds. The fairgrounds could accommodate thousands, which is indicated by the size of the Poultry Building in the background of this photograph.

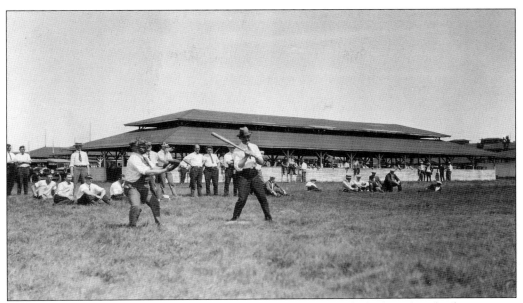

A baseball game, held at a field day at the Erie Exposition Grounds, looks to be a lively one, even though players are wearing hats and ties. The General Electric Athletic Association sponsored the following clubs: archery, baseball, bowling, boxing, football, women's basketball, women's mush ball, golf, gun club, horseshoes, ice skating, men's basketball, men's mush ball, soccer, swimming, tennis, and trap shooting.

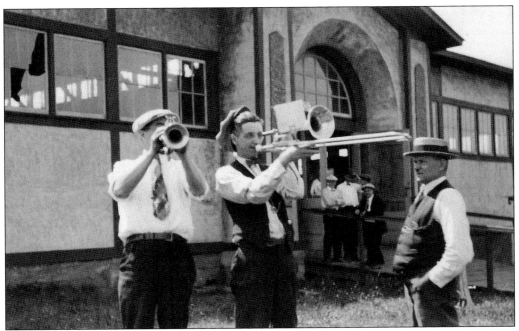

Field day, sponsored by the General Electric Athletic Association, was always an occasion for musicians to "toot their horns." In 1916, the General Electric Athletic Association sponsored a band made up of talented employees.

In 1917, the view from Main Street, looking south along Rankine Avenue, included the Lawrence Clubhouse that later became the home of United Electrical Local 506. The graceful ornamental lamppost that stands on the corner was installed in 1913.

The Lawrence Club, located at the northwest corner of Main Street and Rankine Avenue, stood next to a partially completed row house. In 1918, the Lawrence Park Realty Company bought land from the General Electric Company, upon which these brick row houses were built under arrangements with the U.S. government.

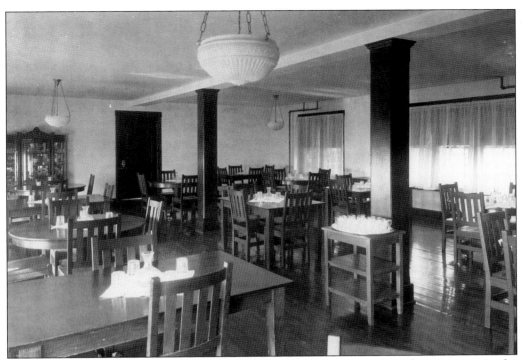

The Lawrence Clubhouse in 1918 contained a large dining room. An advertisement in the *Coupler*, the Erie Works newspaper, in September 1919 stated the following: "The Lawrence Club, located within an eight-minute walk of the factory, offers an ideal opportunity for men looking for a good place in which to live with a homelike atmosphere, where he will find good food, clean comfortable rooms, with excellent table board."

The living room of the Lawrence Clubhouse was a place of comfort for those living there. The General Electric Company had a program for test engineers that necessitated the men rotate assignments and find temporary quarters either here at the club or at private boardinghouses. The *Coupler* advertisement of September 1919 continued to say, "In the Lawrence Club there is a large living room, shower baths, piano, Victrola, barbershop, pool, and billiard room."

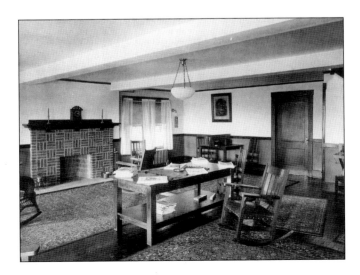

Looking west on Main Street in 1920, the trolley tracks can be seen leading to the east gate of the General Electric Company Erie Works. Some of the commercial buildings that had been constructed on Main Street can be seen in the background.

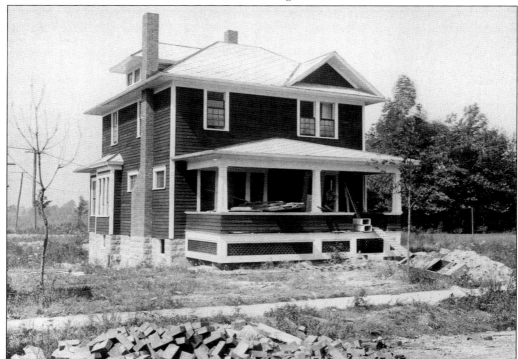

The Edge residence was located on the west side of Rankine Avenue, north of Iroquois Avenue. Many homes were built in 1917 for managers of the General Electric Company Erie Works. Many employees were involved in local government. In fact, from 1926 to 1951, all the commissioners for Lawrence Park, with the exception of three, were General Electric employees.

In 1918, it was popular for little girls to wear big bows. The Bogart children are evidently enjoying a lawn party. The town of Lawrence Park attracted young families with school-age children, which made constructing an addition to Priestley Avenue School necessary.

In the 1920s, big hats and long dresses were the norm. Seen here is Helen, Boyd, and Mary Noyes in front of one of the row houses on Rumsey Avenue. Rumsey Avenue was named for James Rumsey, inventor of the steam-driven boat. (Courtesy of Marjorie Hammers.)

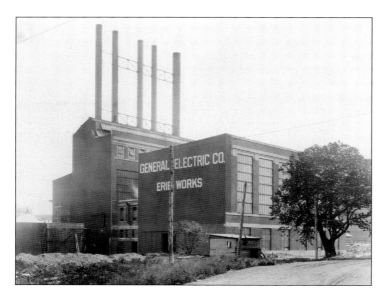

In 1920, the power station at the Erie Works, Building 4, had five stacks. The General Electric power station plot was shown on an earlier drawing as being located on the lake bank within a 50-acre stretch of land, west of Four Mile Creek, which extended from East Lake Road to the bank of Lake Erie. Obviously, the General Electric Company changed its plans to build the power plant for the Erie Works on the lake bank.

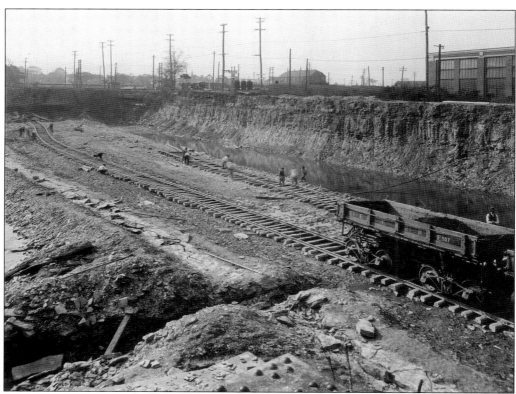

Looking south from the railroad bridge, the near completion of the New York Central right-of-way can be seen. These tracks delineated the southern boundary of Lawrence Park and were, and still are, a busy corridor for the movement of freight and passengers.

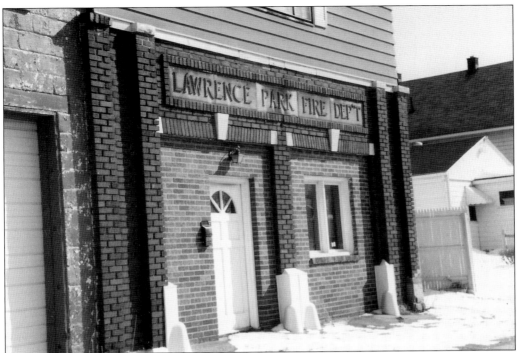

In the 1920s, the firehouse, shown here, was on Rankine Avenue, just south of Main Street. It housed the Ford Ladder and Hook truck, which was used by a group of 25 volunteers under the direction of Alan Chapman, chief from 1912 to 1925. The alarm system was a large bell that was mounted on the roof of Henry Keim's store. Later a Gamewell Fire Alarm System was installed, with 65 red call boxes located throughout the township.

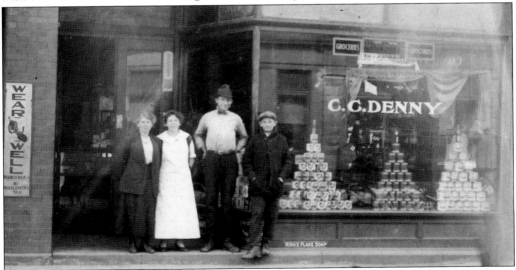

In the 1920s, C. C. Denny, located second from the right, operated a grocery store on the southeast corner of Main Street and Rankine Avenue. This store, which supplemented Keim's grocery store, was needed since the population of Lawrence Park had increased tremendously as a result of building of the row houses in 1917 and 1918.

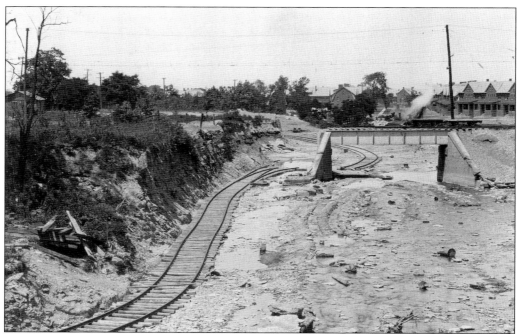

Until 1920, Crowley Road, now Lawrence Parkway or Water Street, made a dangerous grade crossing over the East Erie Commercial Railroad 4.1-mile test track and the Lake Shore Michigan and Southern tracks. A construction project was undertaken to alleviate this problem by building a subway under the tracks that would allow the road, the trolley tracks, and a sidewalk to convey people safely past the railroad tracks.

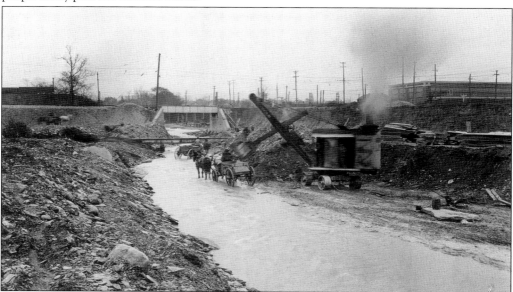

In 1920, it was an arduous task to dig the excavation for the subway that would carry Crowley Road under the test tracks and the railroad tracks. It was necessary to lower the creek bed to enable the subway to be built, but it was worth the effort, considering it eliminated a dangerous grade crossing. The streetcar tracks and a sidewalk would also utilize this subway.

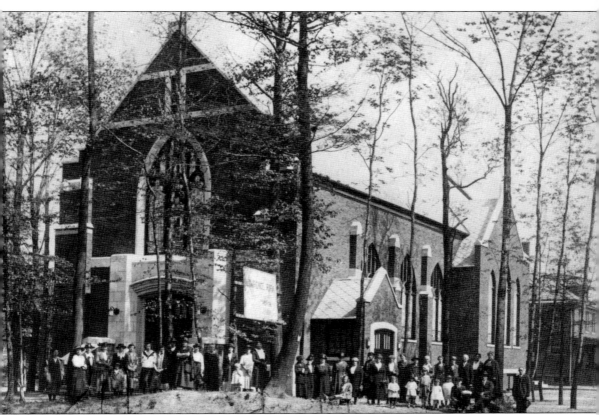

The Lawrence Park United Methodist Church members celebrated the dedication of their church in May 1922. This lovely church, with its beautiful stained-glass windows, is located across from the Elbow Tree Park on Niagara Place. The church was organized in 1918 under the leadership of Deaconess Georgiana Welker, and until their church was completed, the congregation met at the Priestley Avenue School. In 1924, an organ was purchased by the Ladies Aid Society for $1,600. The choir has always added to the beauty of the worship services. The members of the church have been active in civic organizations and have contributed much to the development of a caring community.

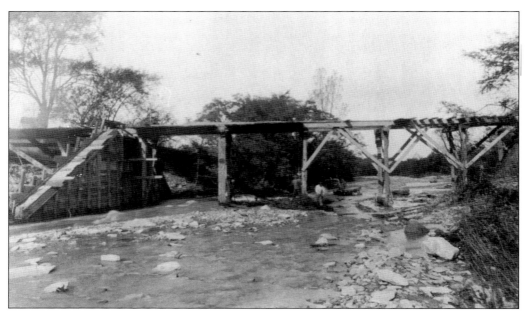

This photograph shows the test track crossing Four Mile Creek on the bridge built in 1920. The General Electric Company purchased the East Erie Commercial Railroad in 1907, allowing the Erie Works to have a 4.1-mile track to test their locomotives. The General Electric Company became a leading producer of locomotives.

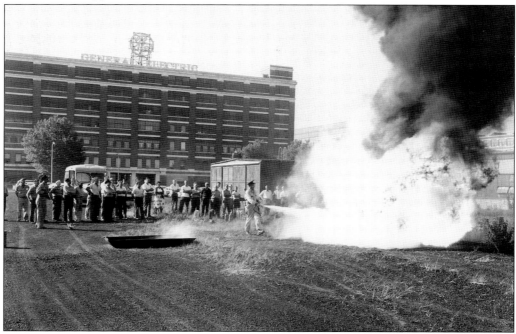

In this photograph, a lesson in fire safety was being given to employees of the General Electric Company Erie Works. For many years, the large General Electric sign on the top of one of the buildings was visible to those passing by on all sides of the Erie Works. It was removed in later years.

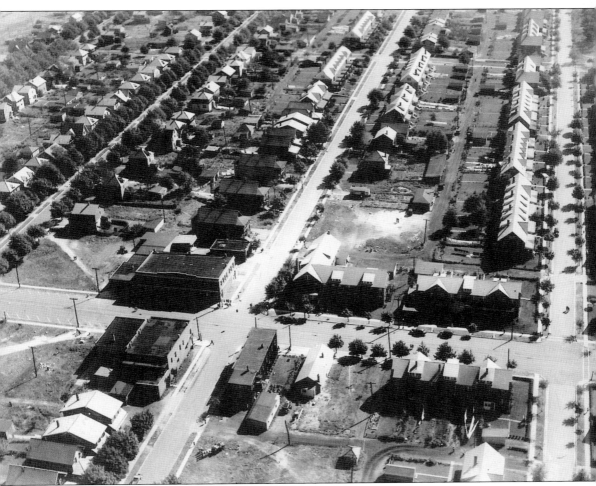

An early aerial view of Rankine Avenue and Main Street shows, in the foreground, Keim's store on the northeast corner and the building that is now Irish Cousins on the northwest corner. Across Main Street is the Lawrence Club. Note the vacant lots next to each of the buildings. The neat rows of houses and paved streets are evidence of the building boom that took place in 1917 and 1918. In this photograph, young trees, planted by the Lawrence Park Realty Company, are beginning to provide shade for the residents of this new town.

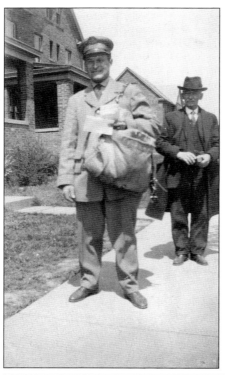

The first mailman to serve Lawrence Park was Harry Cole, who delivered the mail beginning in 1925. Before this time, Col. Wilmer S. Pole would bring mail from Erie and distribute it from his realty office. For many years, Pratt's house at 1014 Silliman Avenue contained a postal substation. In later years, the substation was housed next to 804 Silliman Avenue. It was then moved to the new Township Building, being phased out sometime later.

One of the more desirable homes that were built on lower Howe Avenue was constructed in 1926 and 1927, when Rankine Avenue, Howe Avenue, and Nobel Avenue were extended from Iroquois Avenue to East Lake Road. Howe Avenue was named for Elias Howe, inventor of the sewing machine.

A once popular form of entertainment, the cast of this minstrel show came from the ranks of talented teachers and community members. The General Electric Athletic Association also had minstrel shows for the community, with employees providing the talent. In 1918, the first GEAA show, held at the Park Opera House on North Park Row in Erie, featured the General Electric orchestra and a cast of 70 people.

Claude Austin was the second police chief in Lawrence Park. He and Henry Frick, the first police chief, served together. Austin served the township from 1925 to 1950 and made his appointed rounds on foot, as he did not have a patrol car. He was a friend to all, especially young people, and it is only fitting to have the ball field, located behind Iroquois High School, known as "Claude Austin" field.

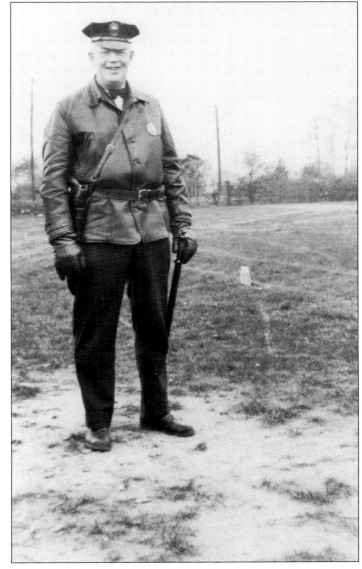

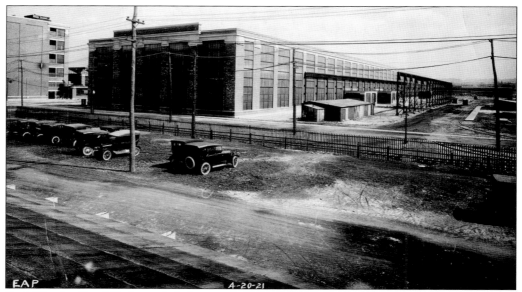

By 1921, the Erie Works included many buildings. Production of equipment for gas-electric motorcars was in full swing, and employment was up. Employees were very sports minded, and to accommodate tennis players, the General Electric Athletic Association built four tennis courts near the main gate. The two courts closest to the GEAA Clubhouse were lit for night play.

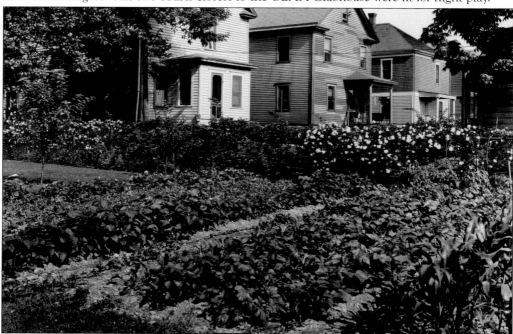

In 1923, the lush backyard garden of C. Wesley Gillespie at 850 Rankine Avenue was a good example of the "English-garden" concept that influenced the developers of Lawrence Park. To encourage victory gardens, in 1917 the Erie Works developed 50 acres of land along the north side of East Lake Road. The company had the land plowed and fertilized and sold seeds and even furnished a watchman.

Four

GROWTH AND PROGRESS

In 1926, Lawrence Park petitioned to become a first-class township, and thus, its own governing body of commissioners and its own school board to oversee the Lawrence Park School District were needed. The building boom of 1917 was followed by more construction in Lawrence Park but at a slower pace. Homes, churches, and business establishments appeared, and streets were extended.

The General Electric Company Erie Works also expanded in both the number of buildings and the number of services provided to employees through the General Electric Athletic Association. At one time, 17 activities and teams were sponsored by the GEAA. One of these eagerly awaited events was GE Field Day, which was an event that occurred every September. In the early years, field day was held at the Erie Exposition Grounds, located in Harborcreek. In 1923, an athletic field and grandstand was built next to Four Mile Creek. This complex was known in later years as Emerson Field. Field day, or Kiddies Day as it was sometimes called, was held here for many years. Unfortunately, field day was discontinued during the years of World War II.

On March 20, 1926, the Lawrence Park Realty Company manager, Willard Howe, announced "the immediate sale of 588 brick homes, a large store building, and a handsome clubhouse, releasing more than $2 million worth of splendid property. Built originally for the government during World War I. Offered for sale at 1/2 the original cost. A four-room house for $2,000. Present occupants given first choice to buy." This sale gave many Lawrence Park residents the opportunity to become home owners.

SINCE 1926

LAWRENCE PARK TOWNSHIP

ERIE COUNTY PENNSYLVANIA

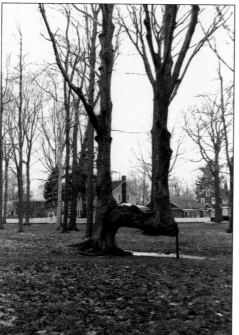

This is the seal that was adopted when Lawrence Park became a first-class township on February 8, 1926, making it the only first-class township in Erie County. With this designation, Lawrence Park had its own commissioners, police department, school district, and could levy taxes. The first commissioners were C. M. Thompson, F. E. Delano, J. A. Eckels, A. E. Frampton, and W. H. Patterson, president. A. E. Swetland was named the first secretary.

The "Elbow Tree" has become the symbol of Lawrence Park, and in 2004, the township commissioners named the park in which the tree stands, Elbow Tree Park. Legend suggests it might have been a Native American trail marker, but perhaps the truth is that it was a sturdy tree with a branch that turned at an unusual angle.

A bird's-eye view from the main gate of the General Electric Company Erie Works shows the growth of the plant. It is interesting to note that along with the growth of the Erie Works, Lawrence Park Township had expanded in various ways, which included temporary quarters and permanent subdivisions that provided gracious living.

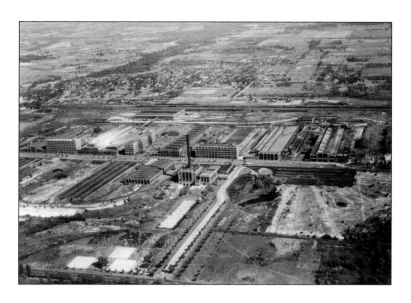

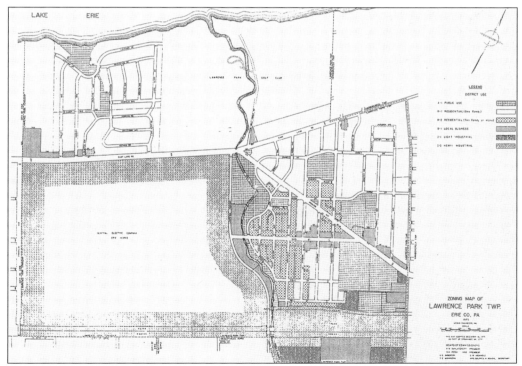

The Lawrence Park township map indicates how the approximately 1.84 square miles are divided into four major areas. At lower left is the General Electric Company Erie Works, the upper left is the Lake Cliff area, the upper right is the area occupied by the Lawrence Park Golf Club, and the lower right plot is the original area of the Lawrence Park town and the Crotty subdivision, which is bisected by East Lake Road and Iroquois Avenue.

There has been a long-standing reciprocal agreement between the volunteer fire department of Lawrence Park, shown here, and the fire department of the General Electric Company Erie Works. William H. Lytle was fire chief at General Electric and also served 32 years as fire chief of Lawrence Park.

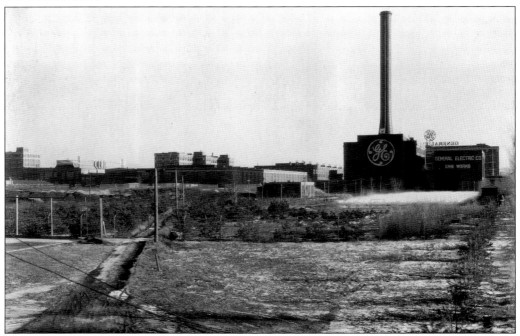

In 1923, the five smokestacks on the General Electric Company Erie Works power plant gave way to one tall smokestack that was 300 feet from the boiler room floor. Not only were people able to locate the Erie Works by this smokestack, but it also became a navigational landmark for the many pleasure crafts that sailed on Lake Erie. The stack was rebuilt and shortened in 1988.

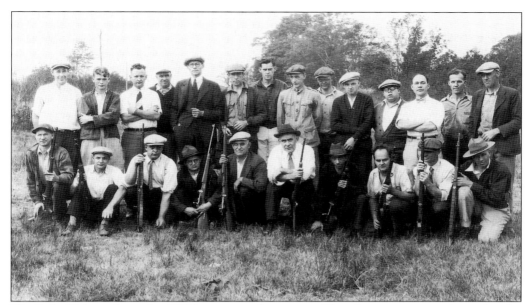

The Rifle Club was formed in 1927 by a group of sportsmen. Their first quarters were located in the Lake Cliff area. At that time, the club was known as the "Sporting Rifles." Their clubhouse was a World War I barracks, and some time later, the members moved the clubhouse to 3818 Field Street. After a time, they outgrew this facility, so they built a new clubhouse at 1396 Nagle Road.

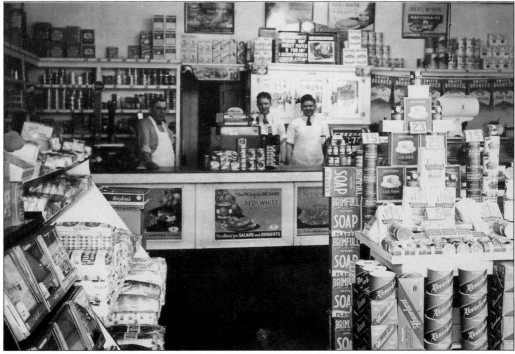

Starks grocery store served the residents of Lawrence Park from 1925 to 1955. Roy Stark, the proprietor, is proudly surveying his well-stocked shelves and counters, with prices prominently displayed. Grocers who followed Stark were Earle Greenlee, Ernie Wolf, and Bernie Sohl.

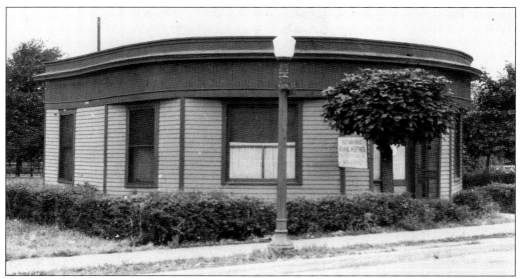

Colonel Pole originally used this distinctive D-shaped building, located on Main Street, as his realty office. In 1928, it was used by the Christian Missionary and Alliance Church as a mission. Before this building was available, the church held revival meetings in a tent. The sign in front of the mission advertises, "Old fashioned revival meeting, welcome."

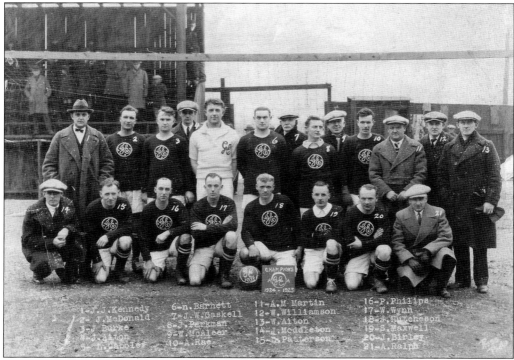

The General Electric Soccer Team pictured here was sponsored by the General Electric Athletic Association in 1929. The club was organized in response to the wishes of the many men from different ethnic backgrounds where soccer was the favorite sport. The General Electric Soccer Team was one of the best soccer teams in the area.

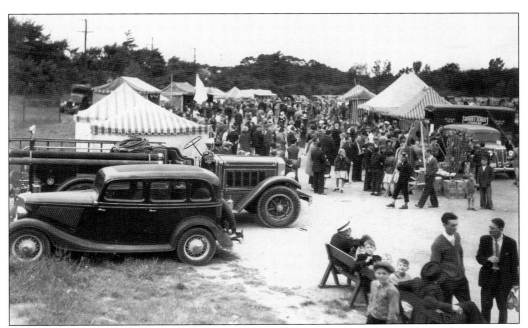

The General Electric Athletic Association sponsored field day and its games, rides, and amusements for many years. This photograph shows a field day that was hosted at the General Electric Field, built in 1923 off Lawrence Parkway and next to Four Mile Creek. A large covered grandstand provided seating for patrons watching the many ball games held here.

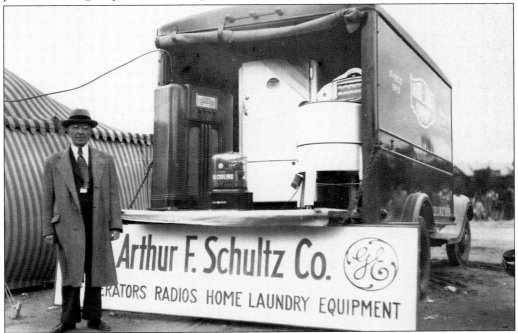

At one of the GE Field Days, a display of General Electric products was shown in the back of an A. F. Schultz truck. Note the size of the radio console. The field days were eagerly anticipated by employees and their families and were usually held the second Saturday in September.

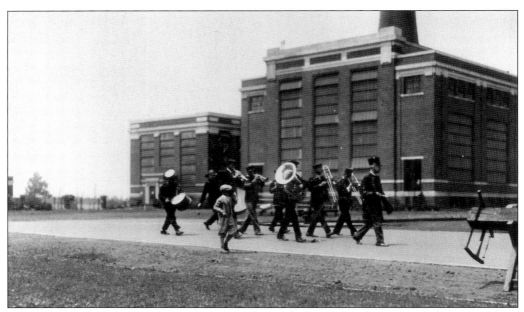

Musically talented Erie Works employees could join the band that the General Electric Athletic Association sponsored. This group performed at various functions such as Memorial Day ceremonies and noon-time concerts for employees. They even marched on the main avenue of the Erie Works.

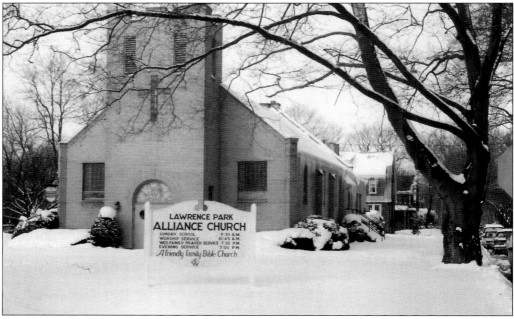

LAWRENCE PARK
ALLIANCE CHURCH
SUNDAY SCHOOL 9:30 A.M.
WORSHIP SERVICE 10:45 A.M.
WED. FAMILY PRAYER SERVICE 7:30 P.M.
EVENING SERVICE 7:00 P.M.
A friendly Family Bible Church

The cornerstone for the Christian Missionary and Alliance Church was laid in 1937 for the basement portion of the church. The superstructure was built in 1945, and in 1963, an annex was constructed. In 1984, the church purchased land on East Lake Road, just past Nagle Road, and sometime later, a new building was constructed there. The building on Rumsey and Napier Streets is now home to the Bread of Heaven Tabernacle.

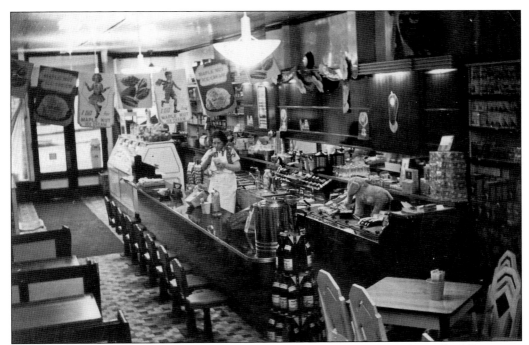

Cherry cokes and root beer floats were very popular at this dairy bar in the Hill Mill store on Main Street. The booths on the left side of the store were usually filled with hungry teenagers. This meeting place thrived during the 1930s and 1940s, with Cliff Peterson as proprietor and Paul Flanigan as manager.

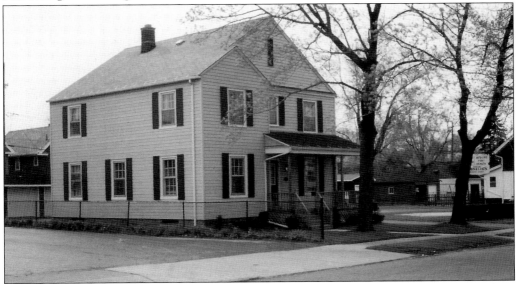

The building at 864 Silliman Avenue served as headquarters for the Lawrence Park Police Department, the Pennsylvania State Police, and the township commissioners from 1926 to 1973. The Lawrence Park police and commissioners in later years moved to the Township Community Center Building on Iroquois Avenue that had previously housed the Lawrence Park Primary School. The state police built a new facility next to the Township Building.

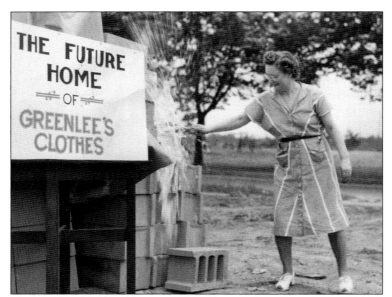

In 1948, Marie Burkhardt Greenlee christened the block at the ground breaking for Greenlee's grocery and clothing store. Marie and Earle Greenlee operated their store at the northwest corner of Smithson Avenue and Main Street. In later years, the building housed Sohl's grocery store, and at present, the American gym occupies the structure. (Courtesy of Sue Dietz Armstrong.)

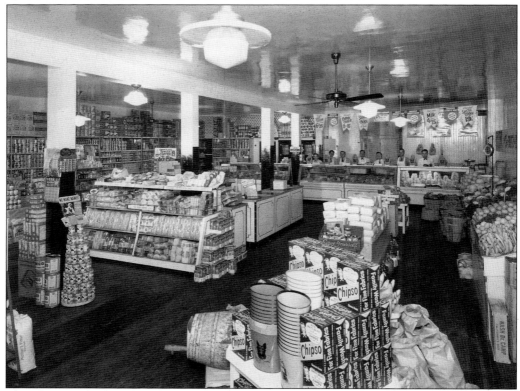

This photograph of neatly stacked groceries, watched over by employees of Greenlee's grocery store, attests that Lawrence Park was well served by grocery stores in the 1940s. This store, operated by Earle and Marie Greenlee, was at the corner of Main Street and Rankine Avenue and was the forerunner of their store at the corner of Main Street and Smithson Avenue. (Courtesy of Sue Dietz Armstrong.)

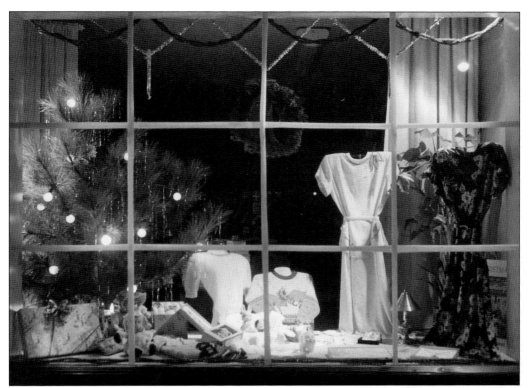

A beautiful Christmas display graced the window of Greenlee's grocery and clothing store. This photograph was taken sometime in the 1940s, and the display featured the latest clothing and accessories that would delight the heart of any young lady. (Courtesy of Sue Dietz Armstrong.)

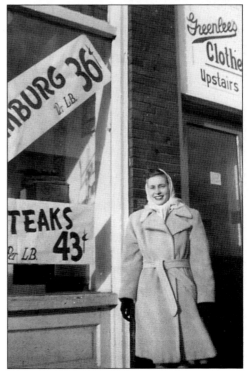

Check out the prices of groceries displayed in the window of Greenlee's grocery store, located on the corner of Main Street and Rankine Avenue in the 1950s. Lee Sanner looked as though she was about to do some shopping. Perhaps she planned on buying steak at 43¢ a pound. In those days, every young woman wore a head scarf to protect head and ears from the cool breezes.

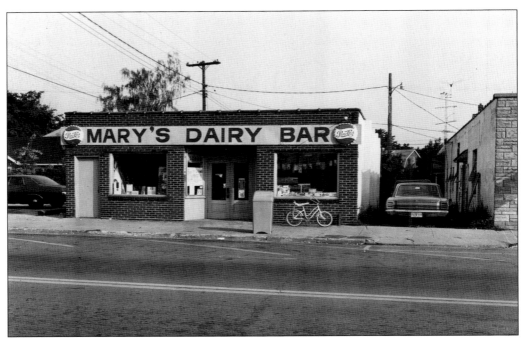

John and Mary Paszko owned and operated Mary's Dairy Bar on Main Street for more than 30 years. This was the after school meeting place, and many a romance began there over a fountain Coke. At Mary's, one could get world news by purchasing a newspaper that was sold there and receive updates on the latest local news through conversations that were had there.

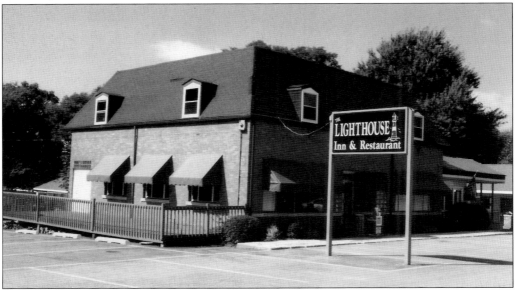

Bernie Soudan built Soudan's Restaurant and Motel in 1947. It was the place to be, particularly after a rousing football or basketball game. In 1971, Soudan sold the restaurant to Bill Underhill, his nephew, who retained the name Soudan's and operated the restaurant and motel for many years. Since 2001, Adam and Jackie Lobenthal have owned and operated the renovated restaurant and motel that is now known as the Lighthouse. (Courtesy of Barbara Klaproth.)

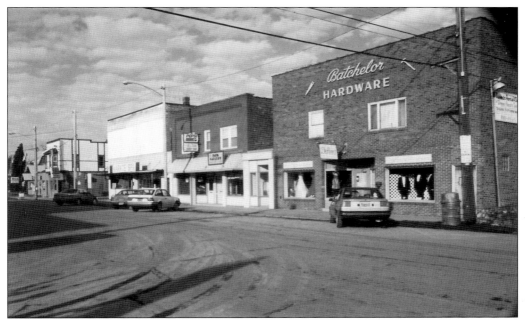

Batchelor Hardware opened in 1946 on the north side of Main Street, between Rankine and Silliman Avenues. Marlow Batchelor soon enlarged the one-story building, adding a second floor that contained apartments. On the west side of Batchelor's, Pete Cole's Dairy Bar, a forerunner of Mary's Dairy Bar, was a popular spot for students to enjoy refreshments and to get started on their homework.

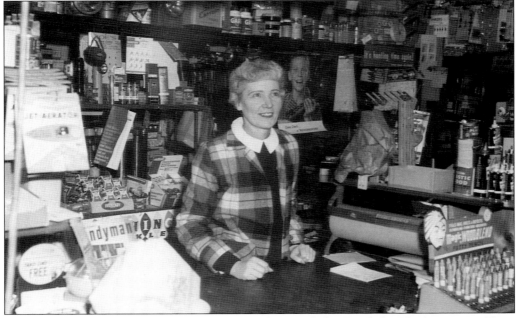

Neal Behringer helped customers find whatever they needed at Batchelor Hardware store. From the looks of the shelves, the store was well supplied. Although Batchelor Hardware is no more, Reece and Doreen Cadwallader have maintained a thriving business there for many years.

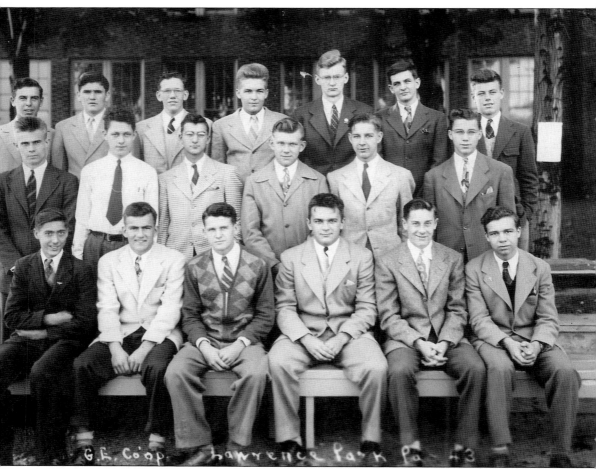

In 1943, during World War II, when the Erie Works was heavily involved in war work and had a need for additional workers, Lawrence Park seniors were released from school to work half shifts at the General Electric plant on a co-op program. Those involved were, from left to right, (first row) Rob Rick, Ron Whipple, Richard Brandenstein, Bill White, Harold Bergstrom, and Richard Sanner; (second row) Tom Gill, David Anderson, Russell Waechter, Jack Anderson, William Schuld, and Tom Patmore; (third row) Ernie Bendig, James Loftus, Murdock McKenzie, Jim Johnson, Harold Garside, Ian MacKenzie, and Glen Yosten.

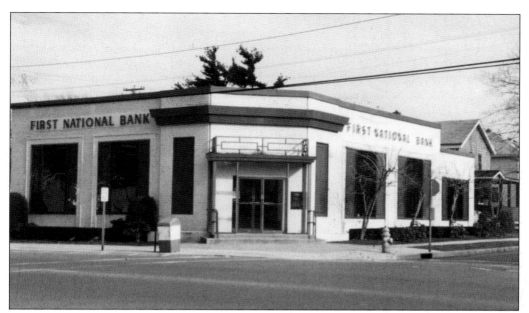

In 1945, the First National Bank replaced the Lawrence Park National Bank that J. C. Spencer established in 1930. On payday, many General Electric workers would descend upon the bank, making it necessary to have security in place. Security consisted of an armed state policeman watching from the second floor of the firehouse, located across the street. In 1999, this building became the home of Americo Credit Union.

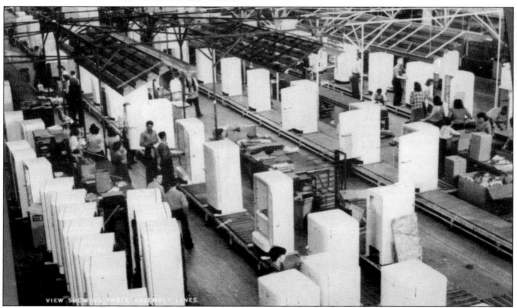

The refrigerator assembly line in 1947 attempted to satisfy the consumer demand for appliances following World War II. Since 1928, refrigerator cabinets, and later complete refrigerators, were manufactured at the Erie Works. In the early 1950s, the General Electric Company relocated the refrigerator production to Appliance Park in Louisville, Kentucky, and with that move, many residents of Lawrence Park were also relocated.

The Glee Club was one of the many activities sponsored by the General Electric Apprentice Alumni Association in the 1950s. The Apprentice Program began in 1913, and its graduates found many satisfying careers in the General Electric Company. The Apprentice Alumni Auxiliary gave the wives of apprentice graduates the opportunity to socialize and contribute to charities. The Apprentice Program was discontinued in 1996.

A familiar sight was the stream of employees leaving the Erie Works, many to return to their homes in Lawrence Park. The General Electric Company Erie Works eventually spread out over 350 acres and had 18 major buildings. Buildings 13 and 17 were constructed in 1941 and razed in 1997. Just after World War II, employment at the Erie Works was at 18,000. By 1988, it had leveled off at 7,000, and today the number stands near 5,000.

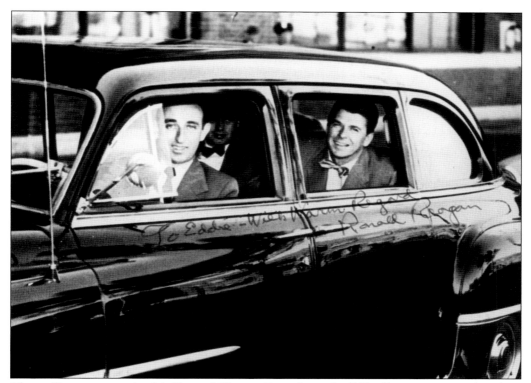

The smiling passenger in this General Electric limo, driven by Eddie Burns, is none other than Pres. Ronald Reagan. In the years before he became president, he was a spokesman for the General Electric Company and visited the Erie Works in 1954. Eddie Burns was the official General Electric chauffeur for many years. (Courtesy of Carol Dolak.)

The Park Pharmacy team bowled at Campell's Bowling lanes in 1946. From left to right are Virginia Curtis, Betty Kellogg, Pat Poly, and Kay Frank. Although no longer used as a bowling alley, one or two of the lanes are still visible on the second floor of what now is Dabrowski's Restaurant and Deli.

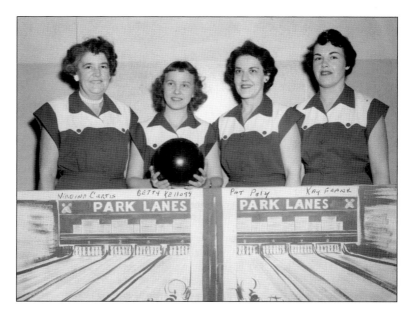

The congregation of St. Mary's Episcopal Church gathered at the dedication of their vicarage in 1956. The vicar's home was built south of the parish house on Silliman Avenue. In 1986, other housing arrangements were made, and the vicarage was sold. In 1958, St. Mary's Episcopal Church erected a modern A-frame church, just north of the Parish House and across from Elbow Tree Park.

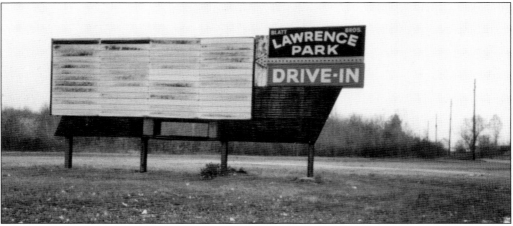

Although the Lawrence Park Drive-In was actually in Harborcreek on Iroquois Avenue, the name allowed people of Lawrence Park to claim it as their own. From about 1938 to 1960, it was a popular spot for a family night out, with kids in their pajamas and parents armed with Kool-Aid and popcorn.

Five

GREEN SPACES

The designers of Lawrence Park planned for green spaces throughout the community. The Four Mile Creek area was the green space that separated the Erie Works from the new town. Building lots were designed to have garden spaces, and more than 700 trees were planted. The original plot map indicates areas for parks and one large park area that became known as Elbow Tree Park.

The township developed Napier Avenue playground, situated along the leafy banks of Four Mile Creek. Other small triangular plots became little parks, such as Beute Park, DePlatchett Park, Memorial Park, and Teker Park. When Lake Cliff was developed in the late 1940s, a strip of land from East Lake Road to the lakefront was designated as a green space that included the Lake Cliff playground and the boat ramp. The small park on the lake bank, next to the boat ramp, is a tranquil area where residents can sit and watch the beautiful sunsets over Lake Erie.

In 1921, employees of the General Electric Company Erie Works requested the use of the land east of Four Mile Creek and north of East Lake Road to build a nine-hole golf course with volunteer labor. The Lawrence Park Golf Club that began in 1921 grew and developed into a premier 18-hole golf course. The members were able to purchase the course from the General Electric Realty Company in 1969.

On the east side of Four Mile Creek, on the bank of the lake, is the General Electric picnic grounds. On the west side of Four Mile Creek, on the bank of the lake, is the Lawrence Park Fishing Club, which was established in 1946 and is still in operation.

When the Crotty subdivision was developed in the early 1950s, it soon became evident that the children living there were in need of a recreation area. The Barringer playground, a ball field, and Teker skating pond were built on the corner of Morse Street and Tyndall Avenue, next to Lawrence Park High School. Lawrence Park was developed with green spaces in mind, and the township has continued to add to this vital community asset.

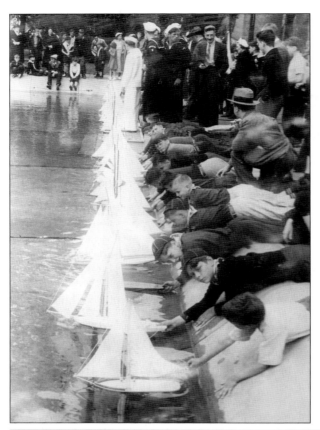

In this 1939 photograph, the Sea Scouts of Troop 17, the "Ship Lawrence," are acting as judges for a Cub Scout regatta at the Chestnut Street pool. Awaiting the signal to launch, each young sailor has a tight grip on his boat. The Lawrence Park Men's Club sponsored the Sea Scout Troop 17.

In 1923, a footbridge, built by the General Electric Company Erie Works, was put in place to connect the GE Field, later known as Emerson Field, and the Napier Avenue playground. Many children and adults have used this bridge to cross over Four Mile Creek, from a ball game to the playground or to cut from the Erie Works to Lawrence Park.

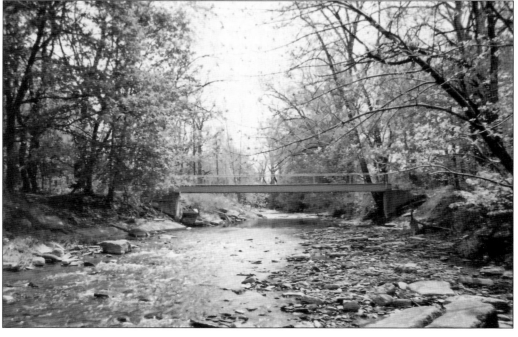

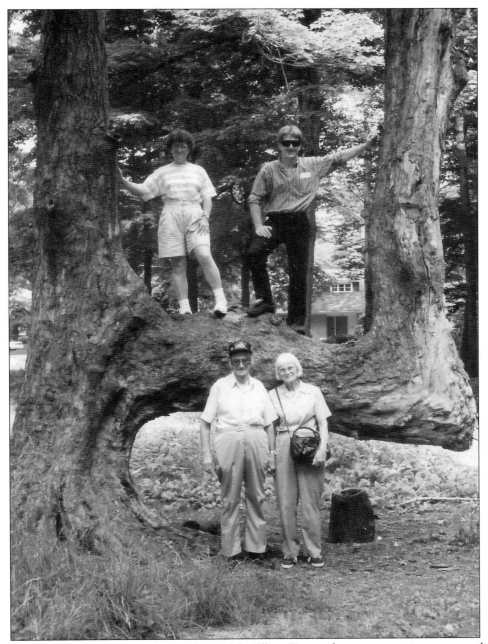

Dick and Phyllis Davis are standing in front of the Elbow Tree and two young visitors are standing on a sturdy branch of the tree. An arborist explained that the tree was forked, with a branch growing out of the trunk of the tree. A weak spot on the tree allowed moisture into it, and a heavy storm allowed the soggy core to bend into a horizontal position. The branch then grew in an upright position. The tree stood for many years; however, it became necessary to dig out the rot, fill the cavity with concrete, and cement an iron rail into the hollow elbow. Finally, in 2005, the Elbow Tree became so unstable that it had to be cut down. On May 29, 2006, a new tree was planted and trained in the attempt to produce a new Elbow Tree.

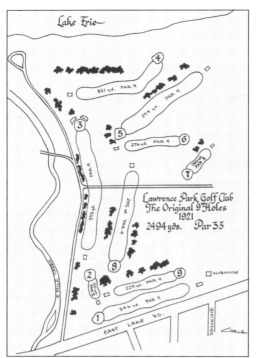

This sketch is of the original nine holes of the Lawrence Park Golf Club. In 1921, a group of General Electric employees requested the use of 75 acres of land, owned by the General Electric Company, on the east side of Four Mile Creek, on which to build a golf course. Matthew Griswold agreed to assist with the project, and Clarence E. Piper designed the layout and directed the volunteers who built the course. (Sketch by Fred Corle; courtesy of the Lawrence Park Golf Club.)

The Noyes family with their 12 children posed for a family reunion portrait beside the O'Lone farmhouse that became the Lawrence Park Golf Clubhouse. They are, from left to right, (first row) Ray, Earl, Mildred (mother), Harry (father), Mildred, and Carlysle; (second row) Walter, Helen, Adah, Mary, Boyd, Harriet, Gladys, Myrtis, and Harry. Gladys Noyes married Carl Wendel, who became the golf professional of the Lawrence Park Golf Club. (Courtesy of Marjorie Hammers.)

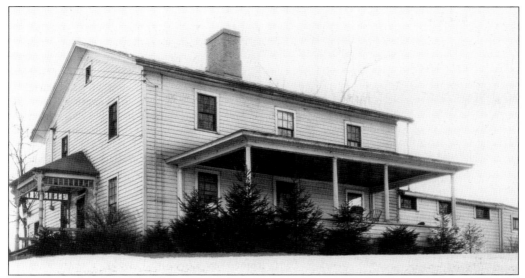

The O'Lone farmhouse was located on the west side of Four Mile Creek. In 1928, Carl Wendel and his wife, Gladys Noyes, moved there. Carl Wendel was the first Lawrence Park Golf Club professional, and the farmhouse became the first clubhouse. The family lived on the second floor and shared their bathroom with the women golfers. The clubhouse occupied the first floor. (Courtesy of the Lawrence Park Golf Club.)

In the early days of the Lawrence Park Golf Club, relaxing on the 19th hole occurred on the porch and the lawn of the O'Lone farmhouse. In 1942, a second nine holes was constructed on land that the General Electric Company purchased in 1919. The General Electric Company owned the course until 1967, when the members of the Lawrence Park Golf Club purchased its 125 acres. (Courtesy of Marjorie Hammers.)

Jean Forsythe was the Lawrence Park Women's Club tournament champion more than 20 times and was the city tournament champion 11 times. Also, she was inducted into the Erie District Golf Hall of Fame in 1983 and Pennsylvania Sports Hall of Fame in 1988. She taught physical education at Lawrence Park High School and at Mercyhurst College. The Jean Forsythe Memorial golf tournament for girls continues to honor this outstanding golfer. (Courtesy of Barbara Behan.)

The entrance to the new Lawrence Park Golf Clubhouse curves up the same hill that took golfers to the O'Lone farmhouse. In 1989, the members of the Lawrence Park Golf Club agreed that the farmhouse was not quite adequate for their needs, so the farmhouse was razed, and a new clubhouse was built. The patio of the new clubhouse has the same delightful views as the porch of the old farmhouse. (Courtesy of Barbara Klaproth.)

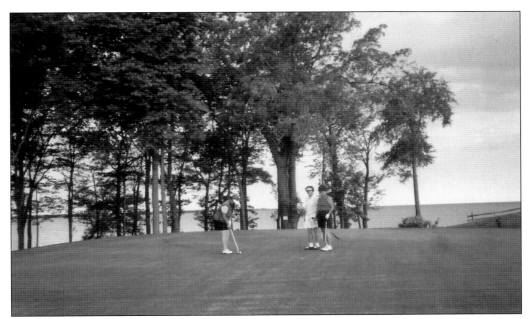

Enjoying scenic vistas of Lake Erie from the No. 1 green at the Lawrence Park Golf Club are, from left to right, Dorothy Bucarelli, Gloria Metzgar, and Marion Spencer. On an old map of the area, the golf course is listed as "Lawrence Park-on-the-Lake Golf Club." (Courtesy of Marjorie McLean.)

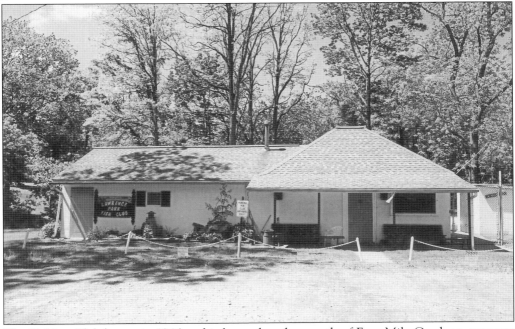

The Fishing Club began in 1946 and is located at the mouth of Four Mile Creek on property originally leased from the General Electric Company for $1 per year. The north section of the clubhouse is the only remaining building of the Four Mile Creek Amusement Park. In addition to a boathouse and club rooms, the Fishing Club has developed a delightful picnic and playground area on the bank of the lake. (Courtesy of Barbara Klaproth.)

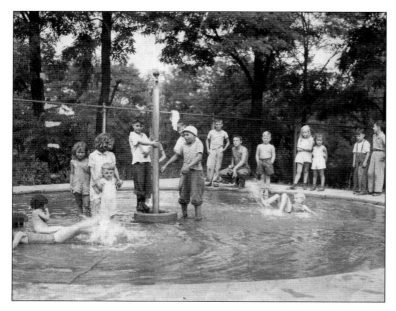

This fountain cooled children at the Napier Avenue playground that was begun in 1930. The area contains a playground, basketball courts, T-ball field, and a picnic pavilion. In 2004, the township named the playground for Charlie Curtis, longtime playground supervisor and Biddy League basketball coach. In 2009, the General Electric volunteers provided and installed new playground equipment.

Here is the Easter egg hunt sponsored by the Lions Club with help from the fire department. Having started in the Lawrence Park area in 1947, the Lions Club not only provides activities like the Easter egg hunt, but also participates in activities such as White Cane Day and the Save-an-eye Football Game.

The Napier Avenue playground has always been a favorite place for kids to wile away the summer days. Nestled in a green valley, the playground provides youngsters the chance to play and explore the surrounding area. Napier Avenue was named for John Napier, the inventor of logarithms.

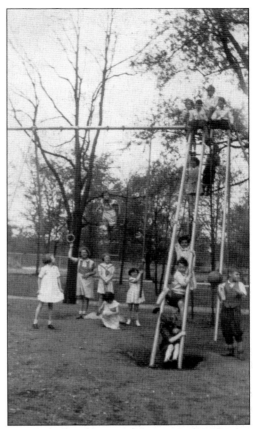

When designing the Lake Cliff area, a wide swath from East Lake Road to the banks of Lake Erie was reserved for green spaces. The township dedicated a part of this to be a supervised playground.

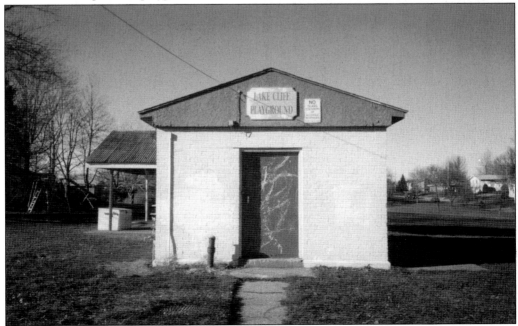

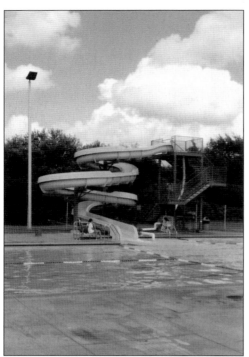

Much to the delight of all the kids, slides were added to the Tri-Community Pools Complex in 1996. The Tri-Community Pool opened in 1977 and was originally covered by a bubble. The YMCA, prior to having a pool of its own, used this pool. During the winter, the walk from the Y through the passageway to the bubble-covered pool was chilly to say the least. (Courtesy of Barbara Klaproth.)

The Tri-Community Pools are sponsored by Lawrence Park, Wesleyville, and Harborcreek. In 1972, an authority was formed to oversee the pools and consisted of three members from each community. Longtime board members are Fred Clark, (Harborcreek), who served from 1972 to 1999; Rev. Al Gesler (Lawrence Park), who served from 1972 to 1996; and Bob Cadden (Wesleyville), who began serving in 1972 and continues to present day.

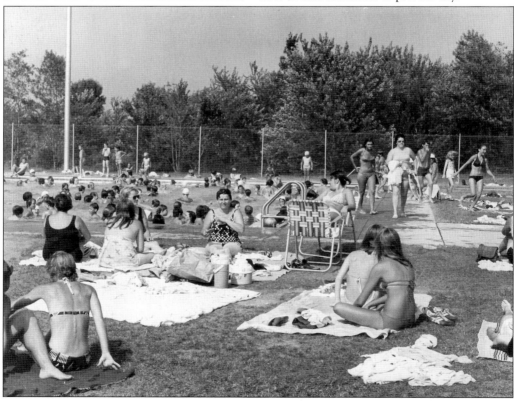

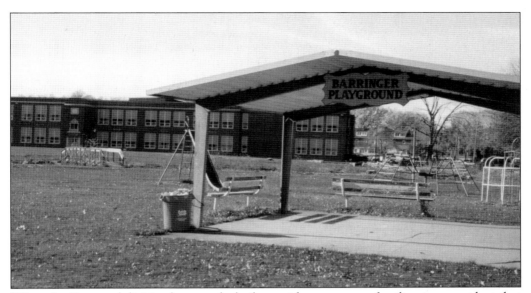

When the Crotty subdivision began to be built up with many young families, it was evident that the young children needed a playground closer to home than the Napier Avenue playground. The area next to the Lawrence Park School was a natural spot for a playground and softball field. It became known as Barringer Playground in honor of Tom Barringer, a legendary basketball coach who lived nearby.

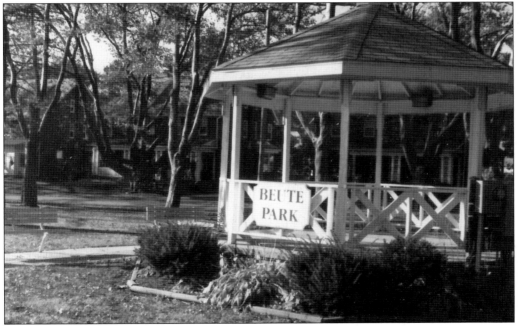

In 2004, Beute Park was named for Albert Beute, a volunteer fireman who died as a result of battling a blaze in 1974. To honor his memory, Richard Sanner, a fellow fire fighter, built this graceful gazebo in the small triangular park bordered by Iroquois and Silliman Avenues and Morse Street. The gazebo is used for summer concerts and for Santa's headquarters on Christmas Tree Night. Morse Street was named for Samuel F. B. Morse, the inventor of the telegraph.

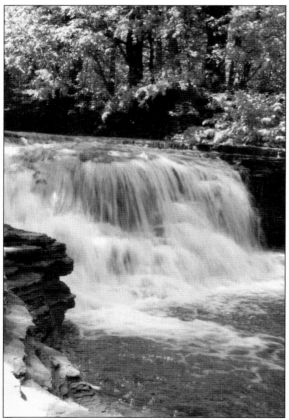

The General Electric Picnic Grove is located on the wooded lake bank on the east side of Four Mile Creek, which is approximately where the Four Mile Creek Amusement Park had been. The picnic grove has a shelter, play area, and ball field where many individuals and families have enjoyed a leisurely afternoon with good food, good fun, and beautiful views of Lake Erie.

This sparkling waterfall graces Four Mile Creek as it flows alongside the road leading to the golf course. It is a familiar sight to those going to and from the Lawrence Park Golf Club, the Lawrence Park Fishing Club, and General Electric Company picnic grove. Those walking or driving to the parking area for the lake also enjoy it. (Courtesy of Barbara Klaproth.)

Six

People Make
a Difference

Buildings, activities, and green spaces are important, but people are the essential ingredient that make up a caring community. Lawrence Park would have to consider Matthew Griswold as the "father" of Lawrence Park. James Sherwin, who arranged to purchase all the land that comprises Lawrence Park, would come in second. Nat White, who headed the Lawrence Park Realty Company, would be a close third. Also important was Col. Wilmer S. Pole, who was in charge of sales and the first president of the Lawrence Park Civic Association.

The following families were among the early settlers: Riley, Wing, Brady, Gillespie, DeBell, Geigle, Bresee, Renshaw, Knight, Kennedy, and Cunningham. Dan Gallagher, a colorful character, was an early resident. On the occasion of the Golden Jubilee of Lawrence Park in 1976, longtime resident Thelma Forsha wrote a poem that told of the history of Lawrence Park. She managed to include the names of 98 early residents and 21 organizations.

The first fire chief was Alan Chapman, who served from 1912 to 1923. Herbert Frick was the first chief of police and was also the truant officer, health officer, and dogcatcher. Henry Keim served residents with his well-stocked grocery store. Harry Cole delivered the mail for many years. There was a postal station at Frances Pratt's for 27 years. Clarence E. Peiper was responsible for beginning the Lawrence Park Golf Club. Dan and Jessie Skala were cornerstones of the Lawrence Park and Iroquois School systems and were directly involved with the foreign exchange student program. Harry K. Rhodes spent many years in the Lawrence Park School System and was also active in various civic programs.

The commissioners who have governed this township have devoted their time and talents for the betterment of the community. There are many more good citizens of Lawrence Park than this space permits to be named, and all of these people are owed a debt of gratitude and a "job well done!"

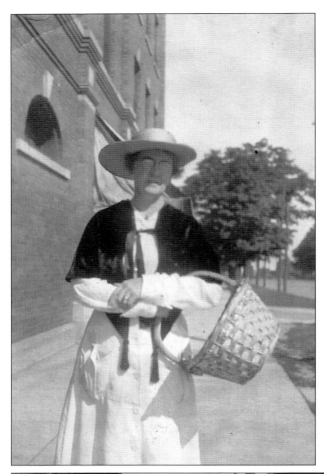

Mary Oaks, complete with market basket, was evidently going shopping in this 1918 photograph. She was the mother of Gertrude Pietre, one of the early settlers of Lawrence Park who was active in civic and political organizations. Gertrude also served with the American Red Cross during World War II.

The Howe Avenue gang played games, picnicked in the park, and, in time, became adults who contributed to the development of Lawrence Park. The group consisted of, from left to right, Neal Shotmeir, Peg Bunny Simon, Margaret Clark Atkin, Bill Forsythe, and Jean Forsythe. (Courtesy of Margaret Atkin.)

Maude Gillespie and her husband, C. Wesley Gillespie, were among the original settlers in Lawrence Park. They lived in the first house built north of Main Street at 850 Rankine Avenue. Both C. Wesley Gillespie and his daughter, Virginia Curtis, recorded much of the early history of Lawrence Park. Virginia Curtis was the mother of Charlie Curtis and was a volunteer at Twinbrook Hospital for 31 years.

Dan Gallagher came to Lawrence Park in 1910 and worked at the General Electric Company as a riveter and molder. For a time, he and his family lived in a tent on the north side of East Lake Road, near the Erie Works entrance. He was a colorful character who, during Prohibition, rebuilt slot machines that had supposedly been destroyed and dumped.

John ("Johnnie") Patrick Cunningham came from Ireland and settled in Lawrence Park in 1918. He began a business that delivered coal and ice and maintained the streets. Johnnie was involved in many civic projects, including the Halloween parade and Christmas Tree Night. During the blizzard of December 1944, Johnnie and his crew worked around the clock to keep Lawrence Park streets and the Erie Works parking lots passable. Behind the houses on the east side of lower Smithson Avenue, he built a skating pond. It had a walled enclosure with benches and a welcoming fire burning in a huge metal can. He was known as the mayor of Lawrence Park, not by election but by popular acclaim. Cunningham Drive, named for Johnnie Cunningham, runs north from Emmet Drive to East Lake Road. (Courtesy of Dee Taylor.)

At Rankine Avenue and East Lake Road, there are stone pillars on both sides of Rankine Avenue. John J. ("Jocko") Kennedy constructed these pillars. Among his many projects were his home at 4019 Iroquois Avenue; the home of his daughter, Jessie Skala, at 4110 East Lake Road; the home of his daughter, Martha Crotty, at 604 Crotty Drive; and the Napier Avenue playground. (Courtesy of Barbara Klaproth.)

Richard B. Davis was one of the police chiefs who served Lawrence Park. Others were Herb Frick, Claude Austin, Henry Stennett, Ed Strong, John Middendorf, Mark Krahe, Harold Herrmann, Gerald Lamb, Charles Lewis, Jerry Pfadt, and John Morell. Lawrence Park has had its own police department since it was originally declared a first-class township in 1926.

A birthday party is usually a happy occasion, but this group of children at Fred Schubert's sixth birthday party seems to be having trouble with being "happy."

The youth of the community in the carefree days of summer are depicted here as these girls cross Main Street at the corner of Silliman Avenue. Located in the background, the fire station, built in 1938, had space for equipment, a conference room, and a recreation room in the basement. Delmar ("Slim") Beatty had a 55-year affiliation with the fire department.

Seen here in this photograph, taken in 1963, are, from left to right, John J. Kennedy, one of the primary forces in the building of St. Mark the Evangelist Roman Catholic Church, and Msgr. Charles Ward, the first pastor of St. Mark's. The church was established in 1938, and Father Ward served his parishioners with dignity and determination until his retirement in 1976.

In 1966, when the move to the new Iroquois High School was completed, the school district offered what had been the Industrial Arts Building on Iroquois Avenue for use by the Erie County Branch Library. The branch library began in 1955 when it was housed in the Priestley Avenue School building, with Jessie Schilken as librarian, a position she ably fulfilled until her retirement in 1976.

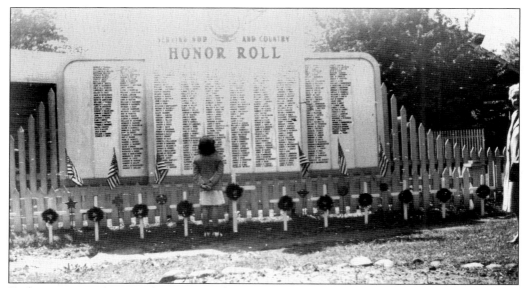

In this poignant photograph, a young girl is searching the Honor Roll for a familiar name among the 342 names of those who served their country during World War II. The Honor Roll was headed by the phrase, "Serving God and Country." It stood in Memorial Park until it deteriorated and had to be removed. When the Honor Roll was taken down, the stone memorial took its place.

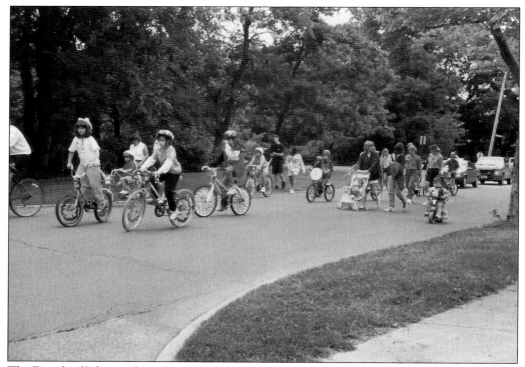

The Fourth of July parade is always preceded by a bike parade, which allows children and parents to be active participants in the festivities. In the evening, a brilliant display of fireworks entertains both young and old, not only from Lawrence Park but also from the surrounding area.

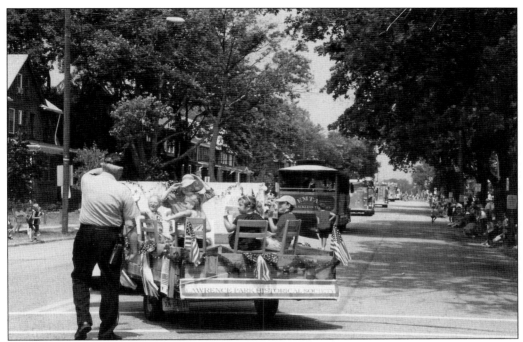

One of the biggest celebrations in Lawrence Park is the Fourth of July parade, with fire trucks, bands, and floats processing down Main Street. This photograph, taken in 2002, shows librarian Jessie Schilken with some of her young readers on the float that is rounding the corner and making its way up Main Street.

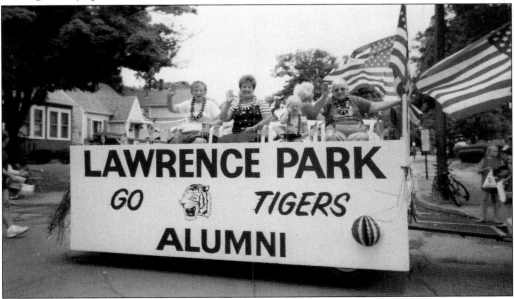

Lawrence Park High School Alumni are an enthusiastic group, as evidenced by these representatives seen on a float that participated in the Fourth of July parade. Their "Go Tigers" spirit prevails, as they are an active group that has monthly luncheons and a summer reunion. They are loyal members of the Lawrence Park Historical Society.

Another "honorary mayor" of Lawrence Park, Raymond "Bud" DePlatchett was a commissioner for a remarkable 36 years. He was also active member in the Lions Club, an honorary fireman, a recreation board member, the president of the Lawrence Park Golf Club, and avid sports booster. Bud was also the president of the Pennsylvania State Association of Township Commissioners in 1987.

John Teker wrote many accounts of the history of the Lawrence Park area, served on the Lawrence Park School Board for 20 years, and was also on the recreation board for 38 years. Teker Pond was named in his honor. He was to be marshal of the Fourth of July parade in 1993, on his 90th birthday, but he sadly passed away on July 3, 1993. The Lions Club dedicated this memorial to John Teker and placed it in Teker Park at Iroquois Avenue and East Lake Road.

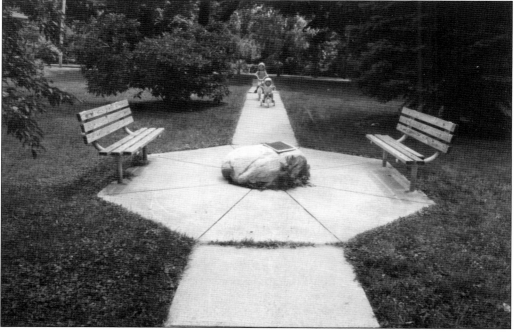

Seven

TEMPORARY AND PERMANENT HOMES

During World War II, the General Electric Company Erie Works was heavily involved in war work. Once again, additional housing was needed, as employment had risen to 12,000. The area directly across from the main gate of the General Electric Company became dotted with 200 trailers and was known as Hunt's Trailer Park. These trailers were more like camping trailers and were removed in the late 1940s.

Another, somewhat more solid, housing development was the Iroquois Court Temporary Housing Project. The federal housing authority constructed 300 cinder-block houses that were all painted white, thus the name "White City." These houses were located south of Main Street and east of Smithson Avenue, the area that Iroquois High School and Athletic Field now occupies. However, as they were intended as temporary housing, they were vacated and torn down in 1953.

In 1947, there was ground breaking for the Lake Cliff subdivision in the area that Hunt's Trailer Court had previously occupied. The initial contracts were to build 170 Cape Cod houses. As late as 1958, the area north of Dobbins to the lake bank was still a woodland that provided an adventuresome play area. Eventually, this area was developed, and attractively landscaped and substantial homes were constructed. France had at one time claimed this area, so developers wished to pay tribute to the early French explorers and early Erie history. The streets include names like La Salle, Frontenac, Joliette, Griffin, Putnam, Wolverine, Dobbins, and Vandalia. As early as 1916, some homes were built on upper Halley and Harvey Streets on the west side of Lake Cliff. The area at that time was known as New Colony.

In the early 1950s, David Crotty developed Crotty subdivision, the area east of Smithson Avenue to Nagle Road and from East Lake Road to Iroquois Avenue. The proximity of the schools and the playground made this an attractive area for young families. These streets were named for inventors like Tyndall, Whitney, and Morse and families such as Crotty, Burkhart, Nagle, and Cunningham.

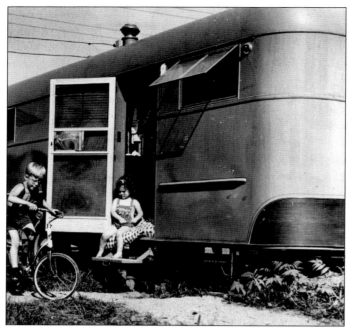

Hunt's Trailer Park helped house workers during World War II. It was located across from the General Electric Company Erie Works, which was where the Lake Cliff subdivision was later developed. The trailers were more like camping trailers, as they had iceboxes and stoves but no sanitary, bath, or laundry facilities. These necessary facilities were provided at several service buildings.

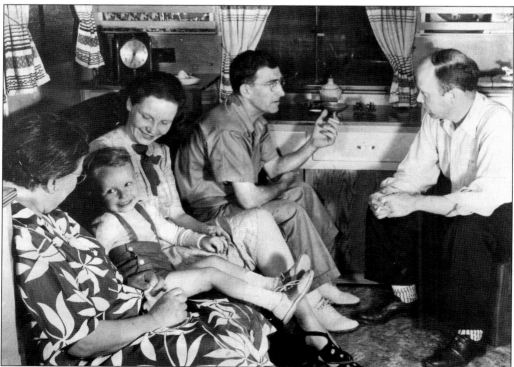

The living room in this trailer at Hunt's Trailer Park was definitely cozy, but B. J. Rogan and his wife still managed to entertain friends in it. The trailers were brought in to house the additional workers during the war. In 1941, employment totaled about 8,000 people, and in 1942, over 4,000 people were added to the workforce.

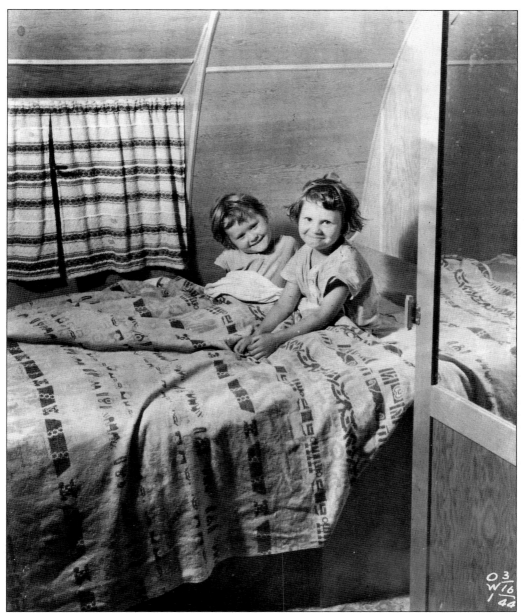

Two kids are tucked in for the night in their bedroom in one of the trailers. By day, the Pullman-like bed folded down into two seats and a table to become a dining alcove. The 200 trailers that had similar bedrooms were located on temporary streets, which were named Kelvin, Huxley, Henry, Herschel, Runser, and Reed. Sometime in the mid-1940s, the trailers were removed and plans were developed to begin building the Lake Cliff subdivision. This area started with the building of Cape Cod houses in 1947, and in subsequent years, many nicely landscaped, substantial homes were constructed. The lakefront property became especially desirable.

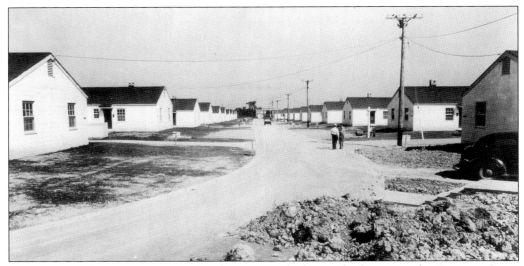

This photograph shows a portion of "White City," which was also known as the "Iroquois Court Temporary Housing Project." It was located in the area that is now the site of the Iroquois High School and Athletic Field. The streets of Spencer and Sherwin were parallel with Smithson Avenue, while the streets of Brook and Field were parallel with Main Street.

From left to right, the three Varhola children, Michael, Andrew, and Alice, were dressed in their Easter finery. Note Alice's Easter hat and big white gloves. They posed near their home in "White City," which took its name from the fact that the cinder-block homes were all painted white. Intended as temporary housing, these homes were vacated and torn down in 1953.

In 1946, Mariene Kwitowski and David Marsala played in front of their home in "White City." The project consisted of 300 low-rental units and a community center that provided an area for recreation and camaraderie.

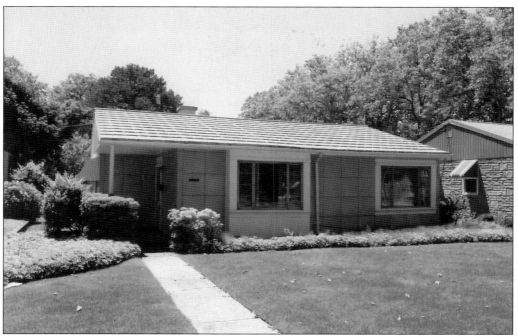

This Lustron home, located at 3907 Iroquois Avenue, was built in 1949. Between 1948 and 1950, the Lustron Company made only 2,498 of these steel houses with porcelain enamel finish. Twenty-two of these homes were sold in Erie, and three of them are located in Lawrence Park. These durable houses were to be the solution to the postwar housing shortage, but financial complications caused this venture to be short lived. (Courtesy of Barbara Klaproth.)

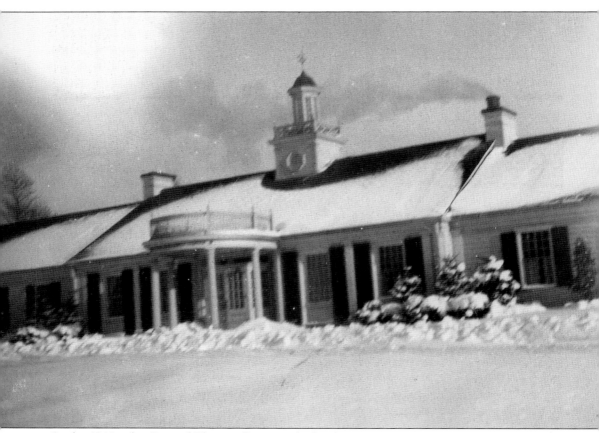

In the 1940s, the General Electric Company built a large, gracious community center near the East Lake Road entrance to the Erie Works. For many years, meetings, receptions, and community events were held here, until the General Electric Company needed the center for business use. When this need ceased in the 1980s, a group of General Electric retirees volunteered to design and staff the Museum of History of Erie Works, which tells and shows the history of the Erie Works and includes information on the beginnings of Lawrence Park. The museum is located in the former community center, and the staff is most willing to share their vast storehouse of information.

Not many people realize that Gindy's Mobile Home Park is partially located in Lawrence Park, although it is south of the railroad tracks. This evidently came about when attorney James Sherwin was buying property for the Lawrence Park Realty Company. The purchase included a plot that extended south of the Lake Shore and Michigan Southern Railway but not quite to the Buffalo Road. (Courtesy of Barbara Klaproth.)

Bordering the Lawrence Park Golf Club property, this attractive home was built in 1951 on Howe Avenue Extension. In 1950, the Lawrence Park Township extended Howe Avenue north of East Lake Road to the golf club property, which provided additional space for several more homes. (Courtesy of Barbara Klaproth.)

These Cape Cod houses were part of the $1.5-million project consisting of 170 homes that began the development of the Lake Cliff area. Present at the groundbreaking ceremonies on July 3, 1947, were H. L. R. Emmet, Erie Works manager, and Charles E. Wilson, CEO of General Electric Company.

David Crotty developed the Crotty subdivision in the early 1950s, and the area attracted many young families. In 1956, this blonde tyke was heading down Crotty Drive to explore parts unknown. The area is located east of Smithson Avenue to Nagle Road and from East Lake Road to Iroquois Avenue. In addition to Crotty Drive, the subdivision includes streets named Tyndall, Burkhart, Morse, Emmet, Whitney, and Cunningham.

Eight

SCHOOLS AND SPORTS

Lawrence Park was planned and developed with a strong emphasis on the importance of education, which is clearly proven in the naming of streets after scientists, inventors, and engineers. In 1911, the Lawrence Park Realty Company assured early buyers that schools would be built to accommodate the community's need, and they were. Priestley Avenue School was built in 1913, Lawrence Park Junior-Senior High School was built in 1924, the Lawrence Park Primary School was built in 1952, the Iroquois High School was built in 1966, and lastly, the Iroquois Elementary School was built in 2007.

The Lawrence Park School District was established in 1926, when Lawrence Park became a first-class township. Many school directors served for long periods of time, as did many administrators and faculty members. Dan Skala began his teaching career in 1931 at Lawrence Park and served for 43 years as teacher, principal, and superintendent. His wife, Jessie Kennedy Skala, began teaching English and directing one-act plays in 1929 and inspired and encouraged students until her retirement in 1971. Harry K. Rhodes is remembered as a principal and superintendent with a rough exterior that covered a heart of gold. Current and former students have a myriad of memories of the many excellent teachers who have taught in the Lawrence Park and Iroquois schools. The academic program has been enriched by programs in art, music, drama, and debate. The Iroquois Marching Band has obtained area recognitions, which are displayed in the form of trophies in the band room.

School sports have brought the community together as loyal fans. A variety of sports provide a team for almost every student. Some of these sports include football, basketball, cheerleading, baseball, wrestling, soccer, tennis, golf, track and field, cross country, and swimming and diving. In more recent years, women's teams have created an enviable record in softball, soccer, basketball, and volleyball. Limited space prevents the naming of the many excellent coaches and athletes. However, the Wesleyville, Iroquois, and Lawrence Park (WILP) Hall of Fame, which began in 2008 (see page 108), is giving recognition to a representative group of individuals who "have distinguished themselves or have made a significant impact on athletes in one of the three schools." Inductees in 2009 were the following: Russell May, Jack Sinnott, Dick Vidic, Sandy Dalglish, Lynn Nelson, Fred Butler, Craig Turnbull, Dan Bokol, and Julie Allen-Parker. Inductees in 2010 were the following: Ed Poly, Skip Kellogg, Phil Glass, Joel Stager, Carrie Turco-Breski, Mary Ann ("Mez") Chilcott, Eric Conley, and Kevin Soles.

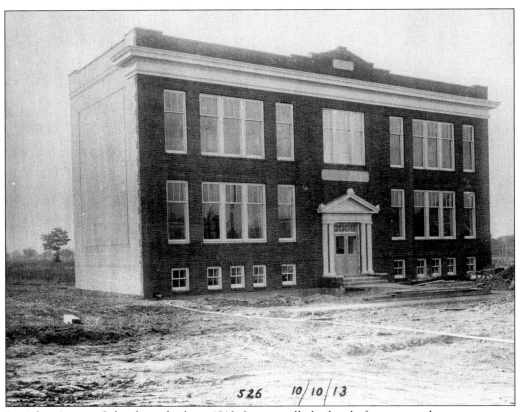

Priestley Avenue School was built in 1913. It originally had only four rooms, but more rooms were soon added. The Lawrence Park Junior-Senior High School was built in 1924. The Lawrence Park Primary School was built in 1952 for students in kindergarten through the third grade, while students in the fourth through the sixth grade remained at the Priestley Avenue School. With the construction of the Iroquois High School in 1966, all elementary students attended the former Lawrence Park High School, and the Priestley Avenue School was vacated and eventually razed.

The fire chutes of the Priestley Avenue School were added to the back and to the side of the building sometime in the 1930s. These chutes were not only used for fire drills but also for Friday dismissals and other special occasions. The process of cleaning the chutes involved students sliding down them on burlap bags. When school was closed, it was fun to climb up the chutes from the outside.

In 1995, the bell that once called students to the Priestley Avenue School found a home in DePlatchett Park, which was named in 2004 for Raymond ("Bud") DePlatchett. The Priestley Avenue School served the community from 1913 to 1966, but with the opening of Iroquois High School in 1966, elementary students were transferred to the former Lawrence Park High School, and the Priestley Avenue School was torn down. The vacant area is now known as Priestley Park.

The school on Morse Street, built in 1924, served the community for many years as the Lawrence Park Junior-Senior High School until 1966 and then as an elementary school from 1966 to 2007. Many residents of Lawrence Park have fond memories of this school and were saddened when it was razed in 2007 to provide space to build the new Iroquois Elementary School.

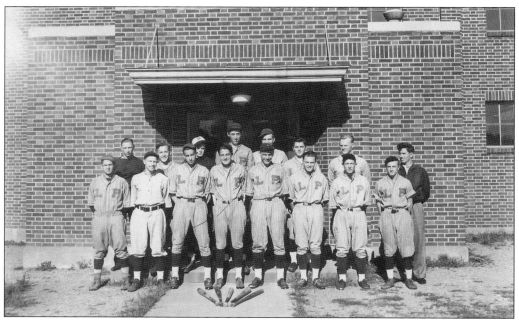

The team members of the Lawrence Park baseball team of 1934 are, from left to right, (first row) Bud Rebuck (captain), Mahue Bennett, Howard Westman, Dick Frank, Al Yeager, Jack Beriger, Ken Koons, and Bob Krupp; (second row) Heine Anderson (coach), Al Massey, Bill King, Clarence Kabnick, Six Randall, Russ Crozier, Bob Cordingly, and Bill Austin (manager).

The members of the 1935 football team were known as the Tigers, and Lawrence Park teams displayed their prowess as such from the 1920s until 1966, when they merged with their longtime rival, the Wesleyville Bulldogs. The teams managed a smooth transition to become the Iroquois Braves and went on to have many winning seasons.

Lawrence Park High School had many championship basketball teams. Pictured here are the members of the 1934–1935 basketball team. They are, from left to right, Ed Noyes, Bud Rebeck, Don Seighes, D. Anderson, Bill King, Al Yeager, Jack Harrison, Bill Phennigan, and Harold Randall. Manager Theiman Lang is posed behind the trophy.

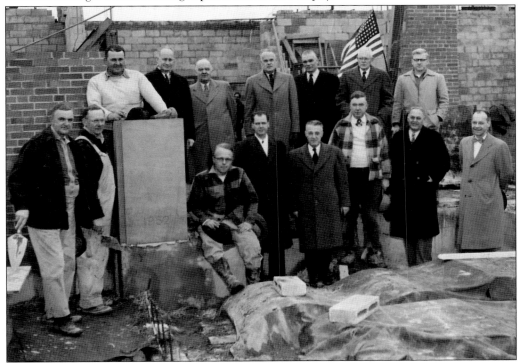

In 1952, the Lawrence Park Primary School was built on Iroquois Avenue. Those participating in the laying of the cornerstone were members of the school board and the school district administration. Those pictured include, from left to right, (first row) Jocko Kennedy, three unidentified, Martin Grotjohan, unidentified, Stan Flaugh, and Dan Skala; (second row) two unidentified, Harry K. Rhodes, William Schryver, Don Meier, Nat White, and unidentified.

Young musicians from the Lawrence Park grade school had fun and learned about music in this rhythm band. Through the use of triangles, bells, and percussion instruments, these youngsters are learning to keep a tempo while working off some excess energy.

The band of Lawrence Park High School in 1956–1957 was a forerunner of the award-winning band of Iroquois High School. This group of talented musicians, although not large in numbers, provided music for listening, marching, and cheering. Howard Schilken was director of the band, orchestra, and chorus.

Ed Poly began teaching and coaching basketball and football at Lawrence Park High School in 1947. As head football coach, a position he held until his retirement in 1977, his teams at Lawrence Park and Iroquois High Schools won more than 100 games, including several Erie County championships. Poly was also playground supervisor and a sponsor of Parkers Haven, which provided social evenings for teenagers for over 15 years. (Courtesy of John Post.)

The women faculty of Lawrence Park High School are dressed for some formal celebration. They are, from left to right, Sue Sack McDanniel, Ruth Carnahan, Ruth McClintock, Irene Rhodes, Jean Forsythe, Lucille Sova, Jean Hartley Paysour Bailey, Suzanne Cummings Rook, Jessie Kennedy Skala, and Bess McBride. McBride was a teacher for 45 years, and 23 of those years were spent at Lawrence Park.

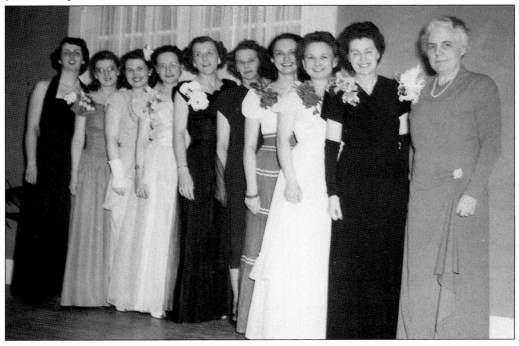

Before being remodeled, the Lawrence Park High School gymnasium had a balcony that was furnished with folding chairs. This area gave spectators a bird's-eye view of the action. Note the piano that might have been used for dances, pep rallies, or musical programs.

Seen here is Supt. Harry K. Rhodes of the Lawrence Park Schools awarding a diploma to a 1954 graduate. He served the school district from 1929 until his retirement in 1966. A take-charge guy, H. K. was a charter member of the Lions Club, built the original Honor Roll, organized the Halloween and Christmas festivities, and was instrumental in bringing the Erie County Library to Lawrence Park.

Dan and Jessie Skala were consummate educators throughout their long careers in the Lawrence Park and Iroquois School Districts. Dan served from 1931 to 1974 as teacher, principal, and superintendent. He was chairman of the American Field Service, and he and Jessie opened their home to 14 students from foreign countries. Jessie began teaching English and directing one-act plays in 1929 and inspired and encouraged students until her retirement in 1971. (Courtesy of Kathy Crotty.)

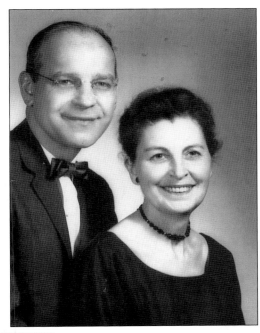

This photograph of Mary Schilken, the daughter of Jessie and Howard Schilken of Lawrence Park, was taken while she was an exchange student in the Philippines in 1960. Under the leadership of Dan and Jessie Skala, Lawrence Park participated for many years in exchange programs that allowed Lawrence Park students to experience a foreign culture and gave foreign students an opportunity to spend a school year in Lawrence Park.

Future major league players got their start on little league teams like this one from the late 1950s. For many years, Lawrence Park and surrounding communities have had little league teams where boys were taught the fundamentals of the game and were instilled with the love of the sport. Members of this team, in later years, went on to be stars on their high schools' varsity teams.

Women's sports at Iroquois High School have had an enviable record. This softball team was displaying their medals when they became state runner-ups in 2006, as did the teams in 1980, 1981, and 1984. Also, Iroquois softball teams were state champions in 1982, 1983, and 1991. (Courtesy of Sarah Johnson.)

For many years, Lawrence Park High School had an excellent basketball program under the leadership of C. Thomas Barringer, known to many as Coach B. He coached at Lawrence Park High School from 1954 to 1965 and at Iroquois High School from 1965 to 1977. This spirited game was one of many basketball games played by a Lawrence Park team.

Thomas Barringer, legendary basketball coach for Lawrence Park High School and Iroquois High School, led his teams to 14 Erie County championships during his 23 years as coach. The members of this 1969–1970 team are, from left to right, Greg Kenney, Bill McLean, Hank Kopnitsky, Tim Smock, Jim Phillips, Frank Moorhead, Tom Barringer Jr., Jim Brickell, Bob Ross, Jack Armbruster, and coach Tomas Barringer. (Courtesy of Joyce Barringer.)

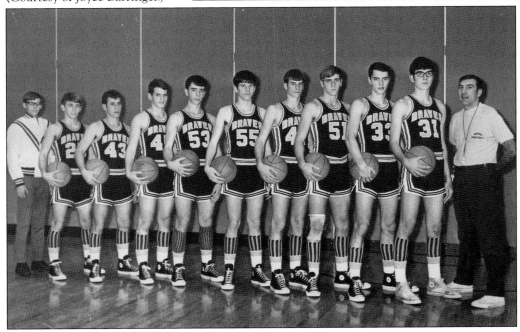

The Iroquois High School was built as a result of the merger of Wesleyville and Lawrence Park School Districts in 1962. The school was constructed in the area that had been occupied by "White City." In the late 1960s, the enrollment was 1,100. Since their new school was not yet completed, the first Iroquois High School class graduated in 1966 from the stage at Harborcreek. (Courtesy of Barbara Klaproth.)

When Iroquois High School was completed, Wesleyville High School became Wesleyville Elementary School in 1966. From 1989 to 2007, Wesleyville Elementary School housed students from kindergarten to the third grade from both Lawrence Park and Wesleyville, and Lawrence Park Elementary School provided schooling for students from the fourth grade to the sixth grade from both communities. Both school buildings had been renovated to accommodate elementary students.

The new Iroquois Elementary School was built during 2006 and 2007 in the shadow of the old Lawrence Park School. This plot of land was the only district property large enough on which to construct the new school, administration offices, and parking lot. In June 2007, much to the regret of many who had attended Lawrence Park High School, the old building was demolished, and the new school was readied for a new school year. (Courtesy of Marjorie McLean.)

The new Iroquois Elementary School, dedicated in September 2007, was the dream of Supt. Dr. Joseph Buzanowski. Sadly, Joe, or Dr. B. as he was known, died unexpectedly in August 2007. Since 2007, the new school has welcomed all students from kindergarten to the sixth grade from Wesleyville and Lawrence Park. Beginning in 2010, four year olds were now able to attend school in the new half-day program. (Courtesy of Barbara Klaproth.)

Artificial turf was installed on the athletic field of Iroquois High School in 2009. This allowed for a safer, all-weather field. Prior to installing artificial turf, in 1976 a group of volunteers installed bleachers and in 1995 another group of volunteers installed lights on the field. (Courtesy of Barbara Klaproth.)

In 2008, the WILP (Wesleyville, Iroquois, Lawrence Park) Hall of Fame was organized. Nominees "must have distinguished themselves or have made a significant impact on athletes in one of the three schools." The 2008 inductees are, from left to right, (first row) Bernard Fitch, Nancy Nelson-Mates, Carm Bonito, Shelly Brown, and Don Wilson; (second row) Jim Cipalla, John Post, Tom Barringer, Dave Ross, Jack Humphreys, and Bill Vorsheck. (Courtesy of John Post.)

Nine

A CARING COMMUNITY

Just as there are many facets on a gemstone, there are many components that make up a caring community. Lawrence Park is fortunate to have had the planners consider that green spaces, schools, and quality housing were essential elements of a solid community. The early settlers of this town were civic-minded individuals who developed organizations that were concerned with the well being of the area. Members of the community have been willing to serve as elected officials, on boards and committees, and as coaches and youth leaders. Churches and schools have cooperated for the welfare of the entire community.

Although dependent on the City of Erie for many things, the residents of Lawrence Park have a wide variety of conveniences within their town, which include the following: playgrounds, pools, convenience stores, ice cream stores, a banking facility, medical center, garages, eating establishments, beauty salons, a library, and even a funeral home.

But the most important things are the organizations and activities that bring the residents together as a family, which, in turn, set Lawrence Park apart from other communities. Young and old enjoy the Easter egg hunts, Memorial Day programs, the Fourth of July parades and fireworks, the alumni picnics and luncheons, Santa in July, a wide variety of sporting events, trick or treat night, and the excitement of Christmas Tree Night in the park.

The motto of the Iroquois High School is the following: "A small school with big pride." And it would only be appropriate for Lawrence Park Township to adopt a similar motto, "A small community with tremendous possibilities."

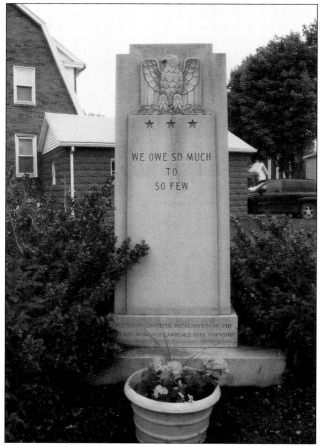

Ever year, Memorial Day services are held at the Memorial Wall that was built in 1995 and located in front of the community center. Ben Baker and Mary Jo King play their bugles to contribute to the ceremony. The wreath was given by Ann Kennedy Howe in memory of her husband, David Howe. The center section of the Memorial Wall is especially poignant as it lists those who gave their lives in the service of their country.

This stone monument in Memorial Park, located at the corner of Iroquois and Silliman Avenues, was erected in 1952 when the Honor Roll board had to be removed. The monument has the following inscription: "We owe so much to so few." And at the base of the monument is the phrase, "Erected in grateful recognition of the men and women of Lawrence Park Township." (Courtesy of Barbara Klaproth.)

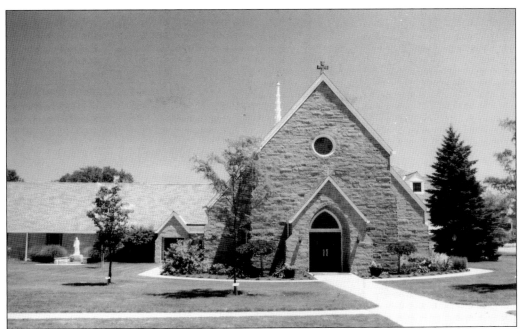

St. Mark the Evangelist Roman Catholic parish was founded in 1938 by Fr. Charles Ward. Volunteer craftsmen from among the parishioners built the social hall and the church. The first Mass was held on Easter Sunday 1942, but on July 30, 1942, a devastating fire swept through the social hall and damaged the main altar. The volunteers resumed building so that by Christmas Eve 1942, Mass was once again offered at St. Marks. (Courtesy of Barbara Klaproth.)

In 1959, Welker Hall was added to Lawrence Park United Methodist Church. This addition was named for Deaconess Georgiana Welker, who was the leader in establishing the church in 1918. The addition allowed room for the growth of their Sunday school classes and Vacation Bible School. (Courtesy of Barbara Klaproth.)

This modern A-frame church was built in 1958 by the congregation of St. Mary's Episcopal Church. Before this time, the congregation worshipped on the second floor of their parish house that was built in 1914. For more than 10 years, St. Mary's has sponsored a community meal twice a month. The church is located on Silliman Avenue and Niagara Street, across from the wooded Elbow Tree Park. (Courtesy of Barbara Klaproth.)

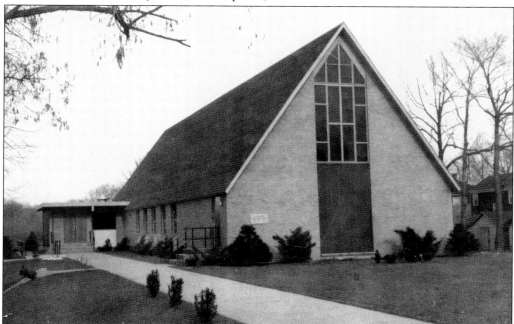

Although Eastminster Presbyterian Church has been organized in Erie since 1907, the church building, shown here, was built in 1959 on East Lake Road, near Halley Street. In 1966, a carillon was installed that serenades the area with melodious hymns. A summer day camp has been held here for many years. (Courtesy of the Eastminster Presbyterian Church.)

This contemporary Christ Lutheran Church was built in 1973. It replaced the more traditional church that was built in 1914 and served the congregation for 59 years. In 1983, Christ Lutheran merged with Redeemer Lutheran, and the congregation assumed the name, Christ the Redeemer Lutheran Church. The Rev. Albert Gesler Jr. served Christ Lutheran Church from 1959 to 1974. The building also houses a preschool program that started in 1974. (Courtesy of Barbara Klaproth.)

An artistic rendering of an angel carved from a tree trunk graced the front of Christ the Redeemer Lutheran Church for many years. This innovative use of nature's leftover was skillfully executed by Billy Drohn.

In 1924, Boy Scout Troop 17, sponsored by the Lawrence Park Men's Club, was chartered at a meeting at the Methodist Church. Troop 17 had a scout cabin built in 1938 that was located near Napier Avenue in the wooded area north of the Napier Avenue playground. Unfortunately, vandals caused the building to burn to the ground in 1952. It was never replaced, but Troop 17 is still going strong.

The members and leaders of Girl Scout Troop 876 pictured here are, from left to right, (first row) Madison Kaiser, Morgan Schnars, Kelsey Steen, Elizabeth Hall, and Jenna Bigley; (second row) leaders Jeanetter Schnars and Mary Steen. The activities of Girl Scout Troop 876 include exploring Presque Isle State Park, sailing on the bay, and enjoying roller-skating parties. There has been a Girl Scout troop in Lawrence Park since 1926. (Courtesy of Jeanette Schnars.)

The Lawrence Park Rifle Club has been in existence since the earliest days of Lawrence Park. Their new clubhouse is located at 1396 Nagle Road, near the Nagle Road Bridge. The expanded size of the quarters will accommodate the activities of the members and the hunter safety education course for youth.

Members of the Lawrence Park Garden Club lovingly tend the grounds near the Memorial Wall. Founded in 1956, their many activities include hosting a spring flower sale, providing flower baskets to beautify Main Street, and creating wreaths for local churches. Planting and tending to flowers on East Lake Road Boulevard, Fritz Evanoff is another volunteer who helps to provide an attractive community.

Safety Town is a unique concept to teach safety to children, as they are about to embark on their journey to kindergarten. This little village that has been sponsored by the Lions Club since 1971 allows instructors to teach them how to get to and from school safely. The members of the Lions Club paint the streets and buildings and set up and maintain the "cars" that are so much fun to drive.

Learning about traffic signals and when it is safe to cross the street are important lessons taught to five-year-old kids in the Lions Club Safety Town program. In addition to "on the road" lessons, there are classroom instructions, a trip to the fire hall, and even a graduation day. The Lawrence Park Township Police Department always plays an active part in the program.

A stop at the Dairy Queen after a ball game has been a tradition in Lawrence Park since 1952, when Reid Woods owned and operated this gathering spot. John Stager was another owner-operator who not only served treats for youngsters and their parents but also provided employment for many high school students.

In 1951, Tom Kalkhof built the Kalkhof Hospital on Field Street. He made several additions to the original building and changed its mission to being a nursing home. In 1984, the Twinbrook Nursing Home was sold but is still serving the area as the Twinbrook Medical Center. (Courtesy of Barbara Klaproth.)

In 1972, a $50,000 addition was made to the firehouse that was erected in 1938 on Main Street and Silliman Avenue. The new addition gave the volunteer firemen more equipment space, while the high doors provided space for larger fire and rescue equipment. The volunteer firemen are summoned to answer the needs of a grateful community by the loud piercing siren that emanates from GE Transportation.

Substituting for Santa's sleigh, the fire truck brings Santa to the Napier Avenue playground for "Christmas in July." The excitement that Santa generates is the same in July as it is in December. Santa's visit is too good to happen just once a year. Fire trucks are also present on Halloween night to ensure young "tricksters" are safe.

Christmas Tree Night, with Santa holding forth in the gazebo, has been a Lawrence Park tradition for as long as anyone can remember. The fire truck brings Santa to Beute Park where long lines await his arrival. Each child gets to sit on Santa's lap and tell him his wish list. Santa's helpers send each child home with a bag of goodies, which is provided by the Lions Club with help from the fire department.

Although the Erie area and Lawrence Park have had few natural disasters, snow and ice storms do occasionally happen. Shown here is the icy beauty of a storm that caused some damage in 1990. Other natural disasters that touched Lawrence Park were the flood in 1915, the tornado in 1924, and the massive snowstorms in 1944 and 1956.

This venerable building, now known as Irish Cousins, has a long history. Located on the northwest corner of Main Street and Rankine Avenue, the building was constructed in 1912 and housed one of the first stores in Lawrence Park, which was where the Halley sisters sold milk and canned goods. At one time, it was known as the Barrel Inn. Owners have included Walt Palmer and Ed Damico, who, in 1970, changed the name to Irish Cousins.

The café that was known for many years as Ma's started in the 1920s as Ma Durands. Located on Main Street near Rankine Avenue, this was an eating establishment for many of the men on General Electric Company programs. They lived in various boardinghouses or at the Lawrence Clubhouse and enjoyed good home cooking at Ma's. Another "Ma" was Ma Thomas who had a boardinghouse at 859 Rumsey Avenue where she fed 60 men in shifts.

The Park Dinor is a prefabricated metal diner that was brought to Erie and assembled at 4019 Main Street in 1948. The spelling of "dinor" is deliberate. Harold Curtis was the first owner, followed by Dorothy and Charles Spiegel, and George Gourlais from 1991 to 2009. It was bought by Rick Standley in 2010. This popular gathering place was placed on the National Register of Historic Places in 2004.

One of the very early structures in Lawrence Park, located on the southeast corner of Main Street and Rankine Avenue, is this building that now houses Dabrowski's Restaurant and Deli, which is known for its pierogies. Other businesses that occupied this building included Campbell's Drugstore and Kellogg's Pharmacy. The Park Terrace and Campbell's bowling alleys were also once located on the second floor of this building.

The Olympic Torch passed through Lawrence Park early in the morning of June 11, 1996. This 84-day national celebration preceded the Olympics being held in Atlanta, Georgia. Crowds lined Iroquois Avenue to welcome the runner who was carrying the torch. It was a thrill for the young ones to have their pictures taken with the torch bearer.

A new modern Iroquois Avenue County Library was dedicated on October 17, 2002. It occupies the same site as the former library, which was housed for 35 years in the former school district's Industrial Arts Building. The architectural style of the new library fits in well with its surroundings, as it is resembles an old-fashioned railroad station.

The United Electrical Local 506 began in 1937 and in 1941 purchased the Lawrence Club on the southwest corner of Rankine Avenue and Main Street. In 1949, a large meeting room was added. The steps of the United Electrical Hall became a meeting place for the young and the restless. In 1980, the building was renovated, and the second floor removed. At that time, a rededication was held, led by Betty Kennedy, wife of United Electrical Local 506 founder Jim Kennedy.

The Lawrence Park Athletic Club (LPAC) on Rankine Avenue has been a local gathering place for many years. LPAC is also an organization that has given generously to many community projects and has provided scholarships for students. (Courtesy of Barbara Klaproth.)

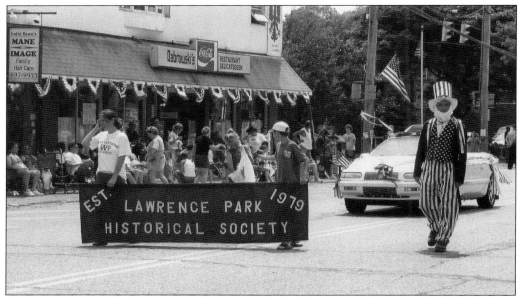

Members of the Lawrence Park Historical Society proudly carried their banner in this Fourth of July parade. Founded in 1979, members work diligently to preserve the history of Lawrence Park. Also, they are involved in many community activities. Their headquarters in the Lawrence Park Township Community Center is open several times a week for interested individuals to browse through 100 years of history.

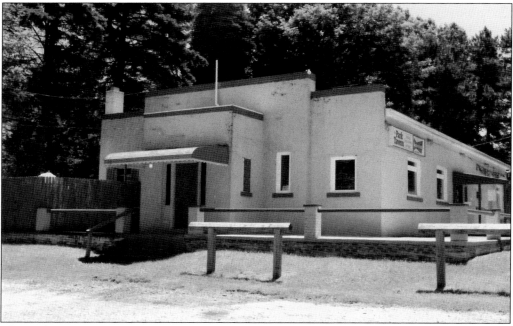

The Park Tavern has been a Lawrence Park bistro for many years. It is a favorite place to recap a ball game or to treat the family to dinner. It has been known by many names, but since 1978, when Bob Leszek took over, it has been called Park Tavern, a name that Cris Leszek, Bob's son, has retained. (Courtesy of Barbara Klaproth.)

An arts and crafts festival was held at Iroquois High School for 20 years, from 1975 to 1995. Many community members worked diligently on this festival that had Donna Knight and Lee Sanner as general chairpersons. Although the craft fair has not been held since 1995, the good news is that the Iroquois School District Foundation is reviving it, with prospects for a fair to be held in 2011.

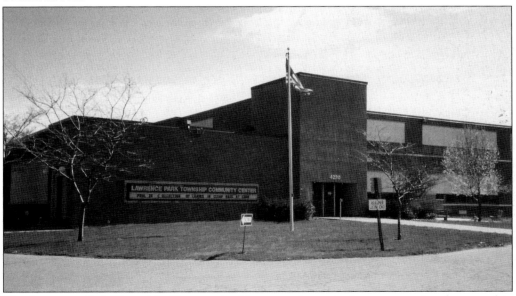

The Lawrence Park Township Community Center on Iroquois Avenue contains the township offices, commissioners' meeting room, police department, and the Lawrence Park Historical Society. The building was originally constructed in 1952 and 1953 to house the Lawrence Park Primary School, which was closed in 1966.

In 2002, the long-awaited Nagle Road Bridge project was about to begin. It would alleviate problems encountered by drivers trying to access Buffalo Road from Lawrence Park. In 1957, the Nagle Road crossing was closed at the railroad tracks because of "light traffic and hindrance to train operations." However, this meant Lawrence Park residents had to use Water Street or Walbridge Road, another grade crossing, to get to the Buffalo Road area. (Courtesy of Art Bennett.)

After many years of discussion, the Harbor Park Bridge, a cooperative venture between Harborcreek and Lawrence Park, became a reality. This meant traffic could safely cross over the tracks and arrive at the "Miracle Mile" that had grown up on Buffalo Road from Wesleyville to Hannon Road. (Courtesy of Art Bennett.)

The dedication of the long-awaited Harbor Park Bridge in 2002 brought together dignitaries from the communities of Harborcreek and Lawrence Park. Those pictured are, from left to right, Pete Ogden, Linda Bebko Jones, Tom Scrimenti, Donna Mindek, Ken Bossart, Ken Springirth, Bud DePlatchett, and Tom Sanders. Rain did not dampen the enthusiasm for the new bridge. (Courtesy of Art Bennett.)

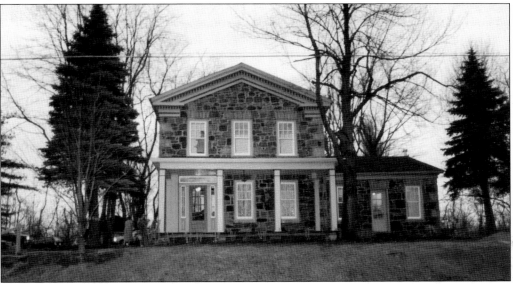

Since this book started with the Stone House and its history since 1832, it is only fitting to end the book with the same Stone House. Thanks to Al and Shirley Deiner, who purchased the home in 1990, the oldest house in Lawrence Park has been lovingly preserved with minimum alterations. The Lawrence Park Historical Society is grateful for their foresight and willingness to preserve this historic structure.

www.arcadiapublishing.com

Discover books about the town where you grew up, the cities where your friends and families live, the town where your parents met, or even that retirement spot you've been dreaming about. Our Web site provides history lovers with exclusive deals, advanced notification about new titles, e-mail alerts of author events, and much more.

MADE IN THE USA

Arcadia Publishing, the leading local history publisher in the United States, is committed to making history accessible and meaningful through publishing books that celebrate and preserve the heritage of America's people and places. Consistent with our mission to preserve history on a local level, this book was printed in South Carolina on American-made paper and manufactured entirely in the United States.

This book carries the accredited Forest Stewardship Council (FSC) label and is printed on 100 percent FSC-certified paper. Products carrying the FSC label are independently certified to assure consumers that they come from forests that are managed to meet the social, economic, and ecological needs of present and future generations.

FSC
Mixed Sources
Product group from well-managed
forests and other controlled sources

Cert no. SW-COC-001530
www.fsc.org
© 1996 Forest Stewardship Council

Find Your Place in History.